W9-DFD-099

Eighteenth-Century French Life-Drawing

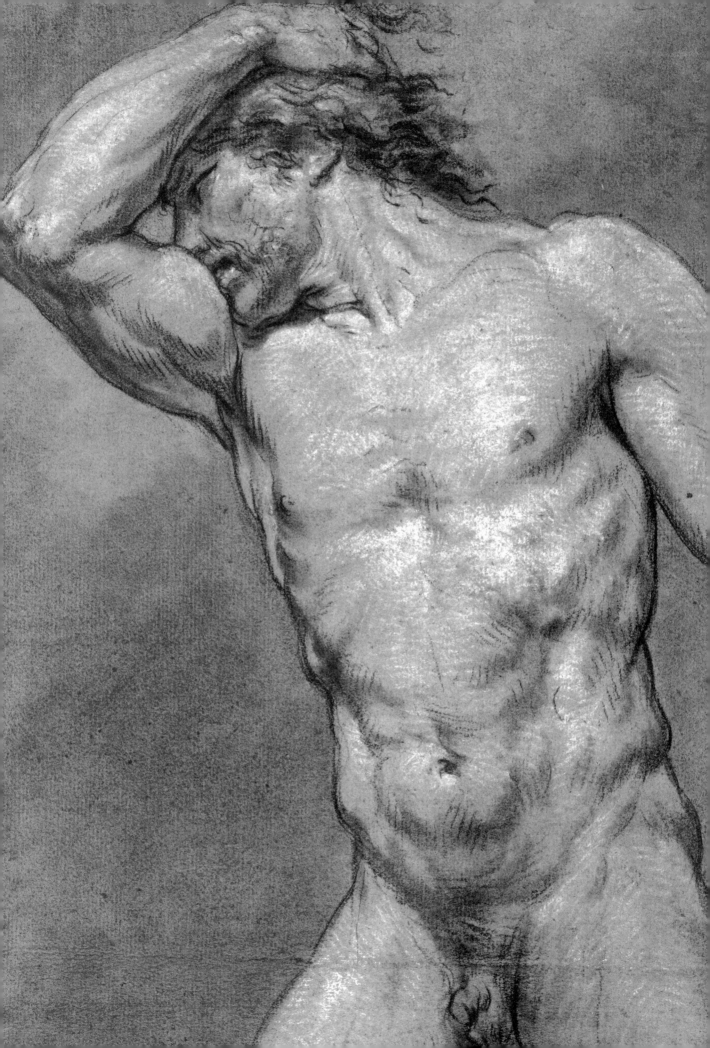

Eighteenth-Century French Life-Drawing

Selections from the Collection of Mathias Polakovits

James Henry Rubin

in collaboration with David Levine

Foreword by Pierre Rosenberg

The Art Museum Princeton University

Distributed by Princeton University Press

Dates of the exhibition: April 2–May 8, 1977

Jacket: detail of no. 3 (Bouchardon)
Frontispiece: detail of no. 15 (David)

Designed by James Wageman
Type set by Princeton University Press
Printed by The Meriden Gravure Company

Library of Congress Catalogue Card Number 76-56719
International Standard Book Number 0-691-03926-7

Distributed by Princeton University Press,
Princeton, New Jersey 08540

For my wife Liliane and my children

Contents

Avant-propos

Après un grand demi-siècle d'éclipse, les études sur l'art du xviiième siècle français viennent de reprendre avec vigueur. Monographies, catalogues de musées ou de collections de dessins, expositions sur tel ou tel "genre" (le paysage ou le portrait en attendant la peinture d'histoire); sur telle ou telle région de France, sur tel ou tel moment (la Régence ou le règne de Louis xv); sur tel courant (les "Piranésiens français")—vont se multipliant, modifiant sensiblement la vision du xviiième siècle que nous avions herité d'un xixème partial, au profit d'une image plus nuancée et plus riche, qui correspond plus précisément à l'idée que le xviiième siècle se faisait du lui-même. C'est dans ce cadre que se place l'exposition des dessins d'après le modèle présentée par le musée de l'Université de Princeton. Quoi de plus logique, au demeurant, et de ré-confortant aussi, qu'une exposition consacrée par une université à un enseignement, car le dessin d'après le modèle fait partie, et ceci dès sa fondation, des raisons d'être essentielles de la toute puissante Académie royale de peinture et de sculpture: enseigner aux débutants à dessiner le corps humain et par là faire des meilleurs d'entre eux des peintres à part entière, c'est-à-dire des académiciens. Sur cet enseignement, on trouvera dans les pages qui suivent, sous la plume de J. H. Rubin, toutes les précisions. Développant les recherches de la fin du xixème siècle couronnées par l'irremplaçable ouvrage de Jean Locquin de 1912, J. H. Rubin étudie l'historique de cet enseignement, sa rude pratique quotidienne comme sa base théorique, ses réussites et sa limite, sa signification aussi.

Il faut savoir d'emblée que s'y sont soumis sans révolte tous les peintres et sculpteurs du xviiième siècle. Et n'y-a-t-il pas au premier abord paradoxe, pour nous qui pensons que l'artiste doit développer dès le départ tout ce qui peut le différencier de ses prédécesseurs, dans cet enseignement qui veut plier l'élève à une discipline, l'obliger à copier, à s'effacer devant les exemples du passé, à imiter autant que possible les recettes de son professeur, et cette peinture du xviiième siècle dont la variété n'a pas fini de nous surprendre. Paradoxe apparent et dont la signification est essentielle à une plus juste compréhension de ce siècle: car cette discipline de fer était aussi une conquête et une libération. Conquête d'une technique, d'un métier dont la maîtrise était jugée in-dispensable, primordiale à toute carrière. Et quand ce métier n'aura plus de raison d'être, l'institution qui permettait de l'acquérir s'effondrera d'elle-même. Mais libération aussi, car cette maîtrise ouvrait les portes aux plus talentueux, à l'idéal artistique de l'époque, peindre l'homme dans sa complexité psychologique, dans sa grandeur et ses misères.

Certes l'"Ecole du modèle," comme on l'appelait, est loin d'être une invention française, mais l'enseignement qui y est professé, minutieusement codifié et réglémenté, connaît au xviiième siècle un développement sans égal, expliquant son rayonnement en province et à l'étranger, le rayonnement par exemple de l'Académie de France à Rome qui le dispensait. Que cet enseignement soit jugé et ressenti comme fondamental, un simple fait en témoigne: de même que le mot Salon signifie aujourd'hui toute exposition de tableaux et même de diverses industries, alors que son nom lui vient du lieu ou étaient exposés au xviiième siècle les tableaux des académiciens, le Salon Carré du Louvre, de même le terme académie a donné son nom, non seulement au genre d'étude qui s'y faisait, mais aussi, par référence aux modèles, au corps humain.

Il nous reste à dire un mot de l'exposition: elle présente les meilleurs dessins d'académie de la collection d'un amateur. Celui-ci, qui s'est consacré avant tout au dessin français, ne s'est pas limité a rassembler sacré avant tout au dessin français, ne s'est pas limité a rassembler seulement des dessins des soi-disant "grands noms" de l'art français. Il sait trop que la liste de ces "grands noms" varie avec les époques. Il aime les petits maîtres, les noms obscurs et même les feuilles encore anonymes. Et si un domaine est par définition anonyme, c'est bien celui du dessin d'académie, rarement signé, ou du moins souvent faussement signé. Ces feuilles ne sont pas préparatoires pour tel ou tel tableau, mais des œuvres achevées; ce sont avant tout des *devoirs d'élèves*, des *dessins de travail*.

On félicitera d'autant plus l'auteur du catalogue d'avoir non seulement réfléchi à la signification profonde des dessins d'après le modèle, mais aussi voulu les attribuer. Paraîtra-t-il superflu d'ajouter qu'il s'agit là de démarches complémentaires, l'une et l'autre indispensables, l'une á l'autre indispensables.

Pierre Rosenberg
Institute for Advanced Study, Princeton
novembre 1976

Foreword

After a half-century of eclipse, the study of eighteenth-century French art has begun to re-emerge with renewed energy. Monographs, catalogues of museums or of collections of drawings, exhibitions of one genre or another (landscape and portraiture, although not yet on history painting); on one or another region of France or historical moment (the Regency or the reign of Louis xv); on a special tendency (the French followers of Piranesi)—such studies have proliferated to the point that they have appreciably modified the vision of the eighteenth century that we inherited from a biased nineteenth century. This development has led to a richer, more nuanced image that corresponds more precisely to that which the eighteenth century had of itself. It is in this context that we must place the exhibition of life-drawings presented by Princeton University. And in addition, what could be more logical, more comforting even, than an exhibition devoted by a university to a form of instruction? For life-drawing was part of the essential *raison-d'être* of the all-powerful Académie Royale de Peinture et de Sculpture since its foundation—that is, to teach beginners to draw the human body and from there to make the best of them into full-fledged painters, ultimately into academicians. On this instruction, one can find in the following pages, in the essay by J. H. Rubin, all the pertinent information. Developing the research begun at the end of the nineteenth century, which culminated in the indispensable book of 1912 by Jean Locquin, Rubin has studied this method of teaching, from its rude and everyday practice to its theoretical base, its successes and limitations, and its significance, too.

We must recall of course that all the painters and sculptors of the eighteenth century submitted themselves to academic instruction without protest. Given our current view that the artist must from the very outset develop whatever can distinguish himself from his predecessors, is there then not a paradox in the coexistence of this teaching method that bends the student through firm discipline and requires him to copy, to suppress his own personality before the examples of the past and to imitate as much as possible the formulas of his professor, and an eighteenth-century painting that continually surprises us by its variety? The paradox is merely apparent, however, and its significance is essential to an accurate understanding of the century: for this iron discipline afforded both a conquest and a liberation for the artist. He conquered a technique, a *métier*, the mastery of which was indispensable, fundamental for any career. And when the technique lost its necessity, the institution that permitted its acquisition collapsed of itself. But it was a liberating experience, also, for technical mastery opened the doors for those most talented to the artistic ideal of the times—to paint man in his psychological complexity, in his grandeur and his misery.

Certainly the *"école du modèle,"* as it was called, was far from being a French invention, but the method of instruction that it professed, minutely codified and regulated, had an unequaled development in eighteenth-century France. This phenomenon explains its spread to the provinces and foreign soil, the latter exemplified by the French Academy in Rome. That its approach to teaching was judged and sensed as fundamental is borne out by a simple fact: just as the word Salon today signifies any exhibition of pictures or, for that matter, of diverse industrial products, although the name originally derived from the Salon Carré of the Louvre, the place where eighteenth-century academicians displayed their work, similarly the term *académie* has lent its name not only to life-drawings generally, which at first had been executed exclusively at the Academy, but, in certain French expressions, through its reference to models, to the human body itself.

A few words must still be said about the exhibition, which presents the best life-drawings from a private collection. The collector, who is devoted above all to French drawing, has not restricted himself to assembling only the so-called great names of French art. He knows only too well, for one thing, that the list of such names varies with the passage of time. Moreover, he has a natural liking for minor masters, for obscure names, and even for anonymous sheets. And if one area is anonymous by definition, it is that of *académies*, which are rarely signed, or at least are often falsely signed. Such sheets, moreover, are not preparatory studies for one painting or another, but are generally finished works; they are above all *student exercises, working drawings*.

The author of this catalogue is therefore to be congratulated all the more, not only for having given thought to the deeper signification of life-drawings, but also for having attempted to find attributions for them. It may appear superfluous to add that these approaches are complementary, indispensable in themselves, indispensable to each other.

Pierre Rosenberg
Institute for Advanced Study, Princeton
November 1976

Preface

The exhibition "Eighteenth-Century French Life-Drawing" and this publication are important contributions to the recently spurred reevaluation of French art in the eighteenth century and the role of academic training in relation to the art of that period.

Mathias Polakovits has made this group of French *académies* from his collection available to Princeton University for study, which has resulted in the present exhibition. He has already made generous gifts to The Art Museum from his collection, with assurance of future gifts from the group of drawings here exhibited. Mathias is in the tradition of the *amateur savant,* an informed collector with interest in the historical significance of his drawings. That he has made the drawings available to Princeton and his past and intended gifts are indices of his appreciation of the role of the university museum and of his commitment to scholarship. Apart from our great debt to him, we must applaud the seriousness of his undertaking. It has been a rare pleasure to share in Mathias' infectious love and enthusiasm for drawings, his knowledge and his respect for scholarly exactitude.

The Art Museum is indebted to Professor James H. Rubin for the direction of the exhibition and to David Levine, a graduate student in the Department of Art and Archaeology, who collaborated with Professor Rubin in the preparation of this catalogue. We are especially pleased that Pierre Rosenberg, Conservateur au Département des Peintures, Musée du Louvre, has added the distinction of his foreword to this publication

Such an exhibition, the scholarly investigation of often neglected but historically crucial material, is the proper focus of a university museum, and this exhibition and catalogue are examples of excellence within that important tradition.

Peter C. Bunnell
Director, The Art Museum

This catalogue, its introduction and its entries, is more than ever the result, in addition to personal toil and travel, of the combined insights, advice, and support of a small community of scholars interested in shedding light on a hitherto neglected subject. It is certainly at least as important for its compilation of their expertise as for my own utterances, and while taking full responsibility for my interpretations of their counsel, I wish gratefully to acknowledge my indebtedness to them. Most important has been the advice and encouragement of Pierre Rosenberg, whose criticisms and bibliographical recommendations have helped me immensely, and without whose attempts to rewrite the history of eighteenth-century French art as something of a precedent, the idea of this exhibition and catalogue might never have been fulfilled. I also wish to express my warmest thanks to Antoine Schnapper, Annie Jacques, Jean Cailleux, Marianne Roland-Michel, Marie-Catherine Sahut, Lise Duclaux, Arlette Sérullaz, Jacques Vilain, Martine Hérold, Regina Slatkin, Agnes Mongan, Konrad Oberhuber, Phyllis Hattis, Emile Wolf, Guy Walton, Thomas Gaehtgens, and Ann Tzeutschler Lurie.

Jonathan Brown, Director of the Institute of Fine Arts, New York University, and Peter Bunnell, Director of The Art Museum, Princeton University, have been untiring in their loyalty and support of this project, and I wish also to thank Virginia Wageman, Kathleen Dobbins, Robert Lafond, Allen Rosenbaum, and Barbara Ross of the Museum staff. I should add that the collaboration of David Levine, who wrote the biographies, bibliographies, technical descriptions, and some entries, went well beyond the concrete evidence of it published herewith, for he offered crucial comments and criticisms that often helped me to clarify my own thoughts.

I would like to thank the Department of Art and Archaeology, Princeton University, for its support of my research and this publication, and the Committee on Research in the Humanities and Social Sciences, Princeton University, for similar support.

Finally, let me say that my greatest debt of all is to Mathias Polakovits, whose irrepressible enthusiasm and encouragement, in addition to his sharp eye and keen appreciation of eighteenth-century draftsmanship, more than once provided the moral spark I needed to carry through with a difficult enterprise.

J.H.R.
October 1976

Academic Life-Drawing in Eighteenth-Century France: An Introduction

16

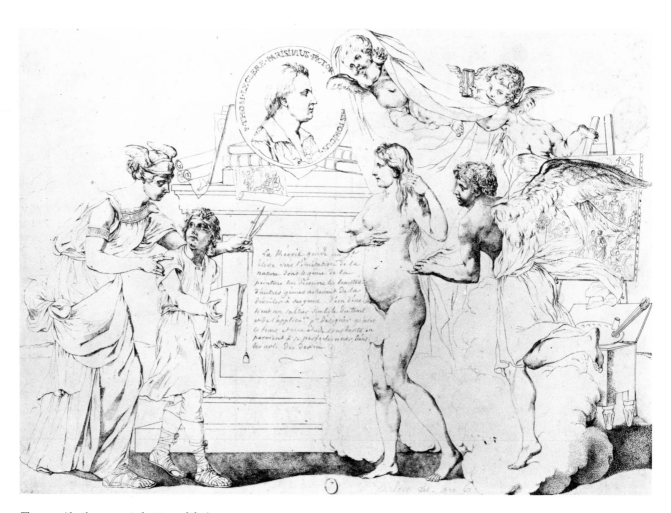

Theory guides the young student toward the imitation of nature, whose beauties the genie of painting reveals to him. Other genies have just uncovered it. One of them holds an hourglass, symbol of time and concentration, in order to indicate that with time and constant study one can attain perfection in the art of design.

Illustration from Sébastien Le Clerc, Principes de dessin d'après nature (Paris, n.d. [165?]), reprinted by J. F. Janinet, Paris, 1798.

The Académie Royale de Peinture et de Sculpture can be studied through numerous documents published in the nineteenth and early twentieth centuries by the French scholars Anatole de Montaiglon, Ludovic Vitet, and André Fontaine.[1] In English, its history has been most skillfully summarized by Nikolaus Pevsner in his *Academies of Art*.[2] There is no need here, then, to discuss the Academy at length, other than to recall a few salient points of its development, especially as they relate to life-drawing, which is the real subject of this catalogue. While some details relating to life-drawing are in fact given by Pevsner, many more are available only in French sources and often only in scattered places. One of the most interesting aspects of this study, in fact, has been the discovery that small practical matters at the Academy, as well as the Academy's careful control over techniques, have determined many features of the drawings we now see. Since nowhere is this kind of information available outside of primary sources, I hope this essay will fill a small gap in the scholarly literature, while providing the average reader with a general introduction to eighteenth-century life-drawing.

While life-drawing was at the very core of the Academy's program as soon as it was established, concern for instruction in the visual arts was less central to its founders than might be suspected. The Academy in 1648 and for many years thereafter was seen as a means to avoid the iron grip over the art trade that had been maintained since the Middle Ages by the traditional painters' and sculptors' guild, the Corporation des Peintres et Sculpteurs, called more briefly the Communauté. It is significant, as Jacques Thuillier has recently pointed out, that the Academy was created by a younger generation of painters who, whatever respect they may have had for their elders, excluded the already well-established Nicolas Poussin and Simon Vouet.[3] The younger men, who included Eustache Le Sueur, Charles Le Brun, Sébastien Bourdon, Henri Testelin, and others, sought to bypass the Communauté's arduous system of apprenticeship, its resistance to the progressive influences of foreign styles, and its preoccupation with matters of mere craft.[4] The academicians constituted themselves as a learned body, and one of the most important traditions they instituted that distinguished them from the guild was a series of *conférences*, or lectures, which usually touched on matters of humanistic art theory and became part of the program of instruction. Since this did not begin until 1667, however, the Academy at first was in fact merely a substitute for the system of the guild and benefited a group of painters who thought of themselves as an elite. Aside from drawing classes, most instruction continued to take place in the studio of the master, each of the professors at the Academy being

18

allowed six individual students. Real differences with the guild—such as the express prohibition of any public display or commercial promotion of the academician's wares—were related once again to the younger generations' perception of a moral difference between theirs as a "liberal art" and the "craftsman's trade" of their rivals.[5]

That drawing classes including the live model were thought to be at the very center of any course of art instruction is demonstrated, if it is not already self-evident, by the fact that this was the only program offered by the Academy at its inception—as if it justified its existence—and the only program that continued without interruption until 1791. Twelve professors, one each month, were responsible for posing the model in a class lasting two hours each normal working day.[6] The classes were theoretically open to all, which in the seventeenth and eighteenth centuries of course meant to all who could show a *billet de protection* from an affiliated master.[7] Members of the guild were thus excluded until 1651, when there was an attempt to fuse the two groups, an unhappy experiment that soon led to renewed quarreling and four years later ended in a complete rupture.[8] The Academy's ultimate victory consisted of its being granted a monopoly over life-drawing instruction. The statutes promulgated by Colbert in 1663 included the requirement that all painters enjoying royal appointments or privilege be enrolled as Academy members.[9] Colbert's creation of a royal subsidy for the body led to the elimination of the small fee for the life-class that had previously been imposed. In one sweeping action, Colbert thus assured the complete centralization of the arts in France and their dependence on the royal authority. Even private life-classes were forbiddenn,[10] although certain private "protected" schools remained,[11] and since no artist could lay claim to any status in educated society without the direct experience of nature to his credit, any sort of rivalry was effectively quashed. From this time on, the only modifications in Colbert's statute concerned the number of models that might be used and the number of hours they might be made available, questions that, because of the Academy's monopoly, were of considerable importance.

Not until the 1750s, when the influence of the Academy was at a low ebb and the protectors of the Communauté were strong, was the guild once again a genuine threat. It had eventually reacquired the right to the live model, and by 1730 it was reconstituted as a rival group called the Académie de Saint-Luc, which had as its protector a disgruntled aristocrat, the Marquis de Voyer d'Argenson.[12] In 1751, it began its own series of exhibitions as a parallel to the Academy's Salons.[13] It was only natural, then, that the royal administration's efforts to revive the Academy should culminate in Turgot's edict of 1776 dissolving the guild and reestablishing a complete monopoly on drawing instruction.[14] More-

over, the Ecole Royale des Elèves Protégés, established in 1748 to give
Rome prize winners three years of intensive study before they left Paris,
was eliminated in 1775.[15]

The Academy's monopoly meant that most eighteenth-century life-
drawings were indeed made at the Academy as part of the process of
instruction—from which the term *académie* used to designate the draw-
ings. They were executed either by a student or by a professor, whose
task it was to set an example. While there are major exceptions—for in-
stance, the drawing after the life made by an established master for his
own edification (as is frequent in the cases of Boucher and Bouchardon),
or more obviously, the drawing meant to be reused for a painted
figure[16]—the term *académie*, and this is particularly true for the nine-
teenth century,[17] generally implies the academic exercise. Moreover,
painted *académies* also exist, especially those sent to Paris by *pensionnaires*
from Rome as evidence of their progress. Famous examples of these are
Restout's *Morpheus* in the Cleveland Museum (fig. 27) and David's *Hec-
tor*, now at the Musée Fabre in Montpellier.[18] The tradition they
exemplify did not begin until well into the eighteenth century, however,
and by 1790 painters seem to have tried to transcend the requirement
that they paint an *académie* in oils. Rather, they produced more ostensi-
bly self-sufficient works, such as Fabre's *Death of Abel* at Montpellier, or,
the supreme example of this kind of effort, Girodet-Trioson's *Endymion*
at the Louvre, which function as history paintings as well as *académies*.[19]

Well before the student reached the state of the painted *académie*, his
drawing from life was judged by his professors and accordingly permis-
sion was given to advance or to compete for the various prizes.[20] But it
would be a mistake to assume that every student at the Academy drew
after the life-model as a matter of course. Life-drawing was naturally his
goal, and by the middle of the eighteenth century it had become the very
definition of the function of the Academy itself: Diderot's *Encyclopédie*
defined an *académie* as "a public school where painters go to draw or
paint, and sculptors to model, after a nude man called the model."[21] But
before being allowed access to this exercise, the student had to show his
proficiency in the two preliminary stages of drawing instruction. At all
stages, advancement from one class to the next was based on the profes-
sor's evaluation of the pupil's competence.[22] It was unthinkable that an
inexperienced pupil should right away confront *la nature*; for drawing
was regarded as a science, and, as one of the most important
eighteenth-century treatises on drawing declared, "the science of draw-
ing can be acquired only after long practice and much concentration."[23]

The first stage in drawing instruction was to copy two-dimensional
works either done by the instructor or engraved after the old masters

(called *dessiner d'après l'exemple*). This meant copying not entire pictures, but profiles, heads, hands, feet, and other details of the body, beginning with eyes, noses, lips, ears, and so on. Some instruction manuals carried as many engravings of these details as they did images of entire figures, and there was always a series of such elements grouped on a plate to give thee student an experience of their diversity (fig. 1). Later the student progressed to copying whole figures.

The reasoning behind this system is relevant to our general understanding of life-drawing. First, the human form was considered the most important object of the painter's study, so he ought to approach it right away. Restricting his attention at first to individual features would, of course, give him a greater intimacy with its details and anatomy before he began to study the entire figure *per se*.[24] Studying flat works, rather than three-dimensional forms, was thought to offer a more simplified beginning. (We might add that it certainly encouraged the acquisition of certain conventions of draftsmanship used to transcribe the three-dimensional subject.) As the student advanced, he was allowed to copy engraved or drawn *académies*; albums of engraved nude figures intended for this or for similar uses (drawing instruction without a master, for example) abound. The best-known engraved plates are by Sébastien Le Clerc, Charles-Nicolas Cochin, Louis Bonnet (fig. 10), and Gilles Demarteau, the last two after Boucher and Van Loo. Cochin's figures were published in various compendiums, including the *Encyclopédie*; Demarteau had been engaged by the Academy itself, and besides the use of his plates in Paris, they were destined for the provincial academies being founded all over France in the second half of the eighteenth century.[25] All these schools, it should be noted, depended on the royal authority and presumably offered the same program of study. Indeed, when the Academy's reserves of original drawings by professors became too abundant, originals, such as a Boucher in the David Daniels collection that carries the stamp of the Orléans academy, were sent to the provinces too.[26]

After spending what Roger de Piles estimated to be about a year with these first exercises,[27] the student in the next stage of his training, which may have lasted several years all together, began to study three-dimensional objects. Drawing after sculpture, usually plaster casts, was called *dessiner d'après la bosse* and was regarded as a necessary transition between flat works and the live model.[28] Its purpose was to familiarize the student with the effects of light and shadow; and he again began with heads and parts of the body, moving eventually to the figure as a whole.[29] Instruction books give little specific indication of how long this stage generally lasted, but in the *Encyclopédie*, Wâtelet recommended that it be more brief than the first stage, since only through such moderation could the obvious dangers of dryness and coldness developed from too much contact with sculpture be avoided.[30] Since Chardin had

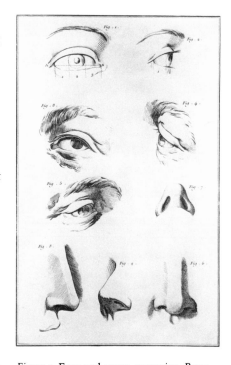

Figure 1. Eyes and noses, *engraving. Reproduced from Diderot, D'Alembert, et al.,* Encyclopédie, *1st ed., s.v. "dessein," pl.* ix.

implied elsewhere that the student was forced to endure as much as he could take,[31] Wâtelet was probably expressing impatience with the stringencies of the Academy rather than a current practice.

The purposes of drawing instruction following this program were summarized by Roger de Piles: "What ought to be the first aim of the beginner in drawing?" he asked. "(1) To accustom his eye to correctness; (2) to acquire ease of execution and to break in his hand to working; (3) to form his taste in good things."[32] In order to achieve the last goal, certain manuals preferred the use of engravings after the great works of the past in the first stage of instruction;[33] and it should be observed, with regard to the second stage, that in any case most plaster casts were made from recognized masterpieces of antiquity. By the time he reached the live model, then, the student could hardly have avoided assimilating certain ideas of how drawn forms should look; that is, he acquired conventions that would remain with him thereafter.

At this point at last, and also after having begun to study anatomy and perspective, the student began to draw after the life-model. The importance of this exercise cannot be underestimated; it was not only the central but the final stage as well in student training at the Academy. Indeed, until the establishment of the Ecole Royale des Elèves Protégés, there was no institutional framework for more advanced work: the practices of oil painting and associated techniques were still located in the private studios of the masters. The founding of an additional school, as Pevsner has pointed out, was surely related to the increased importance of color and of painterly handling in the style of the mid-century;[34] at the Academy, however, the superiority of line was, so far as teaching was concerned, still a well-entrenched doctrine. Even Roger de Piles, the foremost advocate of color, declared in his instruction book that "this art of delineating figures is the foundation of painting," without which, no matter how well one understood colors and light and shadow, "it is impossible to do anything good in painting."[35] Moreover, since the visual arts were defined as arts that imitate nature, no aspect of the course of instruction, save the confrontation with the live model, had such direct relevance to the artist's ultimate and noble goal nor offered such a true measure of the character and quality of what the painter would eventually produce. According to the *Encyclopédie méthodique*, "the student draftsman must through his *académies* give a glimpse of the system he will follow as a painter."[36]

Life-class was held from six to eight o'clock in the morning in the summer and from three to five in the afternoon in the winter.[37] Order of access and seating arrangements were carefully regimented. The posing of the model, which was the first duty of the professor, was done before any student could enter. When the doors were opened, sons of academicians were the first inside. Then came the winners of the *grand prix*, who were led by those who had qualified as *élèves protégés*; other

medalists were next, followed by regular students according to the ranking they had obtained at the annual or, after 1772, semiannual competition.[38] It is reported that in 1764 there were about four hundred students enrolled, while the room in which the life-class took place could actually hold only about one hundred twenty. Classes were to last two hours, but in 1756 there were complaints by professors that it was becoming customary to go on much longer; as a result the old two-hour limit was officially reinstated.[39]

Locquin has pointed out that, unlike in many art schools of today, the model himself was a person of some status: a royal functionary, he was allowed to wear livery and to carry a sword; he had the right to a pension and, like many artists themselves, was lodged at the Louvre. Given the variety of life-drawings, it is amazing to learn that for more than forty years the same model was employed. Named Deschamps or Descamps, he was said by Wâtelet and Levesque to have been studied for "almost all the figures of painting of the French school,"[40] even female ones, since women were forbidden as models at the Academy, and elsewhere were extremely expensive.[41] A drawing dated 1763 and inscribed with the name M. Descamps shows him from the rear (no. 38). And an anecdote involving Jean Restout's use of Descamps, combined with Wâtelet's description of his face as "*un peu bachique*,"[42] leads us to suspect that it is he who appears in the Cleveland *Morpheus* (fig. 27), for which we have discovered an important study (no. 29). Could the man who appears in a drawing by François Boucher (fig. 14), and who reappears in a much weaker drawing of similar technique and related style and period (fig. 2), also be Descamps? This face, familiar from other Boucher drawings of the 1730s (fig. 30 offers an excellent comparison), possibly reappears in other drawings in the present selection (nos. 19, 24, 26, and 28). There were other models, too, of course, such as the one who appears in *académies* by Charles Natoire (see no. 27), some of which were made to be engraved.

A drawing by Natoire (fig. 3), another version of which is dated 1745 and mistakenly inscribed *Académie de peinture à Rome*,[43] shows the life-class in Paris, where Natoire had been a professor since 1737. While it appears to show the disorder and crowding of the class, its description is actually somewhat programmatic. In the center of the organization, two models pose together—a monthly occurrence[44] (see Largillière's famous *double académie*, fig. 4)—and are observed from different angles by a variety of students. In the foreground, from left to right, Natoire himself, seated, advises a student on his drawing, while another student, who is looking on, waits his turn to show his own work. Near the center and slightly farther back, possibly waiting his turn too, sits a student who muses over the work he seems just to have completed. At the far right, a student who has probably finished for the day washes his hands. The

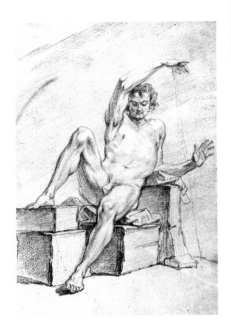

Figure 2. Anonymous, Seated man holding a staff, *red chalk. Paris, collection of Mathias Polakovits.*

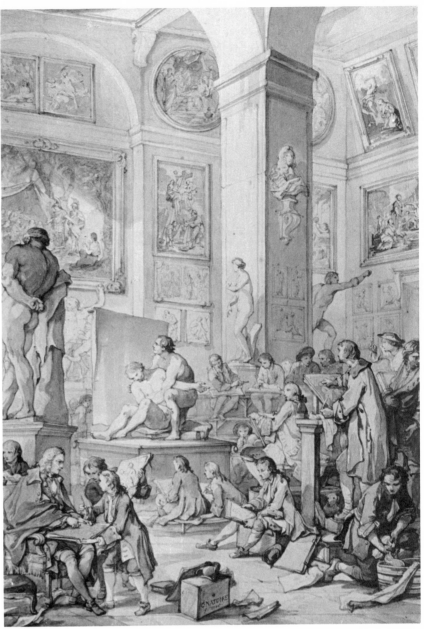

Figure 3. Charles Natoire (1700–77), Life-class at the Academy, *watercolor over black chalk, signed and dated 1746. London, Courtauld Institute of Art (Witt Collection).*

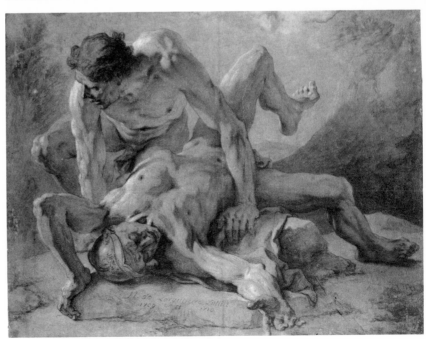

Figure 4. Nicolas de Largillière (1656–1746), Two men struggling together, *black and white chalk on brownish paper. New York, Metropolitan Museum of Art, Purchase, 1969, Rogers Fund, 69.10.*

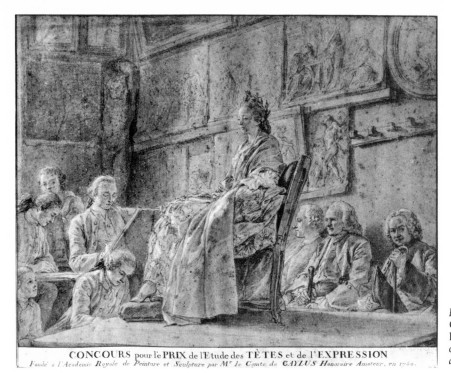

CONCOURS pour le PRIX de l'Etude des TÊTES et de l'EXPRESSION

Fondé à l'Académie Royale de Peinture et Sculpture par M^r le Comte de CAYLUS Honoraire Amateur, en 1760.

Figure 5. Charles-Nicolas Cochin (1715–90), Competition for the prize for the study of heads and expression, black and white chalk on gray paper. Paris, Musée du Louvre, Cabinet des Dessins, RF2054.

Figure 6. Cochin, School of drawing, engraving. Reproduced from Diderot, D'Alembert, et al., Encyclopédie, 1st ed., s.v. "dessein," pl. I.

whole scene is surveyed from high up on a pillar by a bust, presumably of a king or some other noble protector. Casts after famous antique marbles are another reminder of the noble enterprise at hand. Finally, the walls are hung with examples of great works by former academicians— Le Brun's *Tent of Darius*, Jouvenet's *Descent from the Cross*, and Bourdon's *Rest on the Flight* (all reversed), to cite the best known. According to Dacier, the exact location of the room was on the first floor of the Louvre where there is now a stair landing, just to the right of the *Victory of Samothrace* and just before the vestibule of the Galerie d'Apollon (fig. 5).[45]

An illustration (fig. 6) by Cochin, who was secretary of the Academy, represents a drawing school and is accompanied by a ground plan showing an arrangement in amphitheater form with wooden stands for seating. We can observe something of this sort already in the Natoire drawing; it is not used in the present image, however, since this has as its purpose not the depiction of an actual place but the suggestion of the step-by-step process of instruction. To the left are seated two very young pupils. The smallest, whose feet do not even reach the ground, copies a drawn or engraved head, while the second, who is receiving criticisms from the instructor, has copied an entire figure. Above them hang plaster casts of heads and parts of the body, which will be used in the second stage of instruction, drawing after *la bosse*, which is shown in the center. The students here are noticeably older and appear to be copying from the original of a modern master rather than from a cast after the antique, which would be larger and of different style. To the right, Cochin has next represented the life-class itself: its students may be yet older than the middle group. The brightly lit model stands on a podium, with one knee raised up by a box and cushioned on a pad. The purpose of this particular kind of position was to contrast the movement of the two legs, while other attitudes served similar purposes, as one easily surmises after viewing a number of *académies*. With his right arm, the model holds a rope suspended from the ceiling; the left arm is posed with the aid of a wooden staff, another significant contrast. These mechanical aids to the model appear frequently in *académies* and were prob-

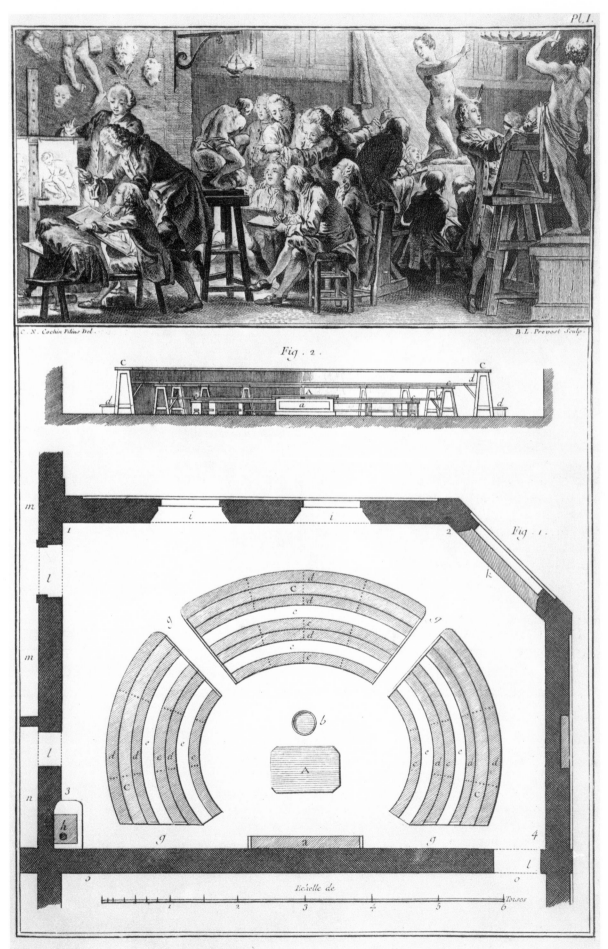

Pl. 1.

C. N. Cochin Filius Del.

B. L. Prevost Sculp.

Fig. 2.

Fig. 1.

Echelle de

Toises

Ecole de Dessein.

ably used because the model had to endure the same pose for at least two hours, a pose that usually seems to have been changed twice weekly.[46] The student to the far right is a sculptor drawing in soft clay after the antique: he uses a different, more chisel-like drawing instrument, and he holds a sponge in his left hand.[47]

Notice in all the exercises the use of artificial lighting, which was necessary in the winter, but, in addition, obviously lent itself to more control. Its use is even more clearly visible in a little-known drawing by Cochin (fig. 7), which in a more casual manner than the Natoire shows the students seated in tiers with a professor in the foreground examining a student's work.[48]

Treatises on art in the late seventeenth and the eighteenth century were of two sorts or had two parts—theoretical and practical. Typifying the former, the *Traité de peinture* of 1765 by Dandré-Bardon, despite its great amount of detail, still treated drawing only in the abstract. Dandré-Bardon's chapter on draftsmanship is concerned with *correction*, *caractère*, *goût*, and *expression*; and even where he dealt with the *"principes du dessin fondés sur les vérités de la nature,"* the author selected natural qualities such as *souplesse* and *âme* because they could be antidotes to *manière*. A drawing with "soul" would, for instance, express the flexibility of a hero's musculature, since this was the key to his physical agility. Dandré-Bardon provided no precise formula for attaining this quality generally, however, since his book was primarily aimed at the careful formulation of critical principles for the use of both painter and connoisseur. The most specific practical advice he offered was the commonplace suggestion that the draftsman should combine his observations of nature with the beauties of the antique.[49]

The practical approach, which interests us much more here, was that espoused in the books of Roger de Piles (1685), Gérard de Lairesse (1719), and Charles Jombert (1740).[50] These are instruction books, and while they may occasionally lapse into theoretical verbiage—as a concession, no doubt, to those who saw drawing as nobler than mere craft—their usefulness in their own time and their interest for our purposes reside in the practical and technical indications they contain. Jombert is extremely useful for his attention to just this sort of detail and, since it had a quickly exhausted first edition in 1740, Locquin's claim that it became a classic is not surprising.[51] The treatise by Lairesse, despite its non-French origin, was also exceedingly popular, probably because of its concise, step-by-step approach to drawing instruction in fourteen lessons. Although it was not necessarily intended for the use of the Academy, it is an excellent guide to teaching there, too, since so much of its content repeats or is repeated by the other books. Perhaps the best source, however, is ultimately none other than the *Encyclopédie*, which by declared intention was both representative and all-encompassing. At

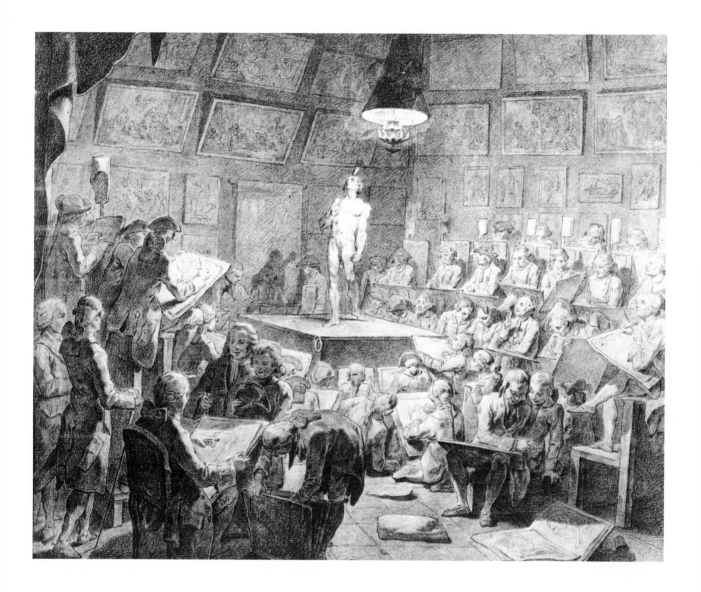

Figure 7. Cochin, Life-drawing class, *chalk drawing. Collection unknown.*

several points therein, however, the superiority of Lairesse's method was cited; in particular, he was praised for commencing his instruction program with the study of simple geometric figures, followed by the imitation of common inanimate objects, such as candlesticks or bowls.[52] Others, in contrast, believed that, since the pupil's ultimate goal was to study the human form itself, it was a waste of valuable time not to begin immediately by copying drawings of heads and their features.[53] It was mainly the difference on this point that distinguished Lairesse's program from that of the Academy. However, since a pupil needed an attestation that he had acquired the rudiments of drawing before he could enter the Academy's classes, he might have had early instruction similar to that proposed by Lairesse. In any case, Lairesse's program

from lessons seven through fourteen was identical to the Academy's and to that of other instruction manuals.

Figure 8. Drawing instruments, *engraving.* *Reproduced from Diderot, D'Alembert, et al.,* Encyclopédie, *1st ed., s.v. "dessein," pl.* ii.

The student of drawing always began by working with red chalk (*la sanguine* or *le crayon rouge*) on white paper.[54] This was true whether he worked from drawings, from casts, or from the life-model, although we presume that he really only moved seriously to more complex techniques when he was a full-fledged member of the life-class. (We shall therefore be discussing technique only in relation to the last.) The reason for insisting on the restriction to red chalk on white paper at the beginning of instruction was related, obviously, to its simplicity when compared to alternative combinations, which always involved tinted papers. The latter required heightening with white chalk (*la pierre blanche* or *le blanc de craie*) for the brightly lit areas, since the color of the paper—generally blue or gray—was thought to establish the half-tone.[55] The artist working on white had no need to heighten and worked through all values toward the deepest shade with always the same chalk. Simpler in its vocabulary, the technique on white paper was on the other hand much slower, since, according to the *Encyclopédie méthodique*, the too-harsh contrast between the color of the chalk and the whiteness of the paper required softening through the half-tones the artist himself was required to create.[56] From the point of view of instruction, however, this inconvenience had the singular advantage of forcing the student to be methodical. In addition, since red chalk was harder to erase than other chalks, the student had to take greater care in order to attain the cleanliness and finish that were other indications of his proficiency.[57] Only the more experienced draftsman was allowed the convenience offered by tinted papers of limiting what he recorded to the more extremely lit or shaded areas. But it should also be observed that the clarity—indeed the schematism—of the red on white technique was also a pure exercise of draftsmanship. The use of tinted papers and other chalks—principally black chalk (*la pierre noire* or *le crayon noir*), as distinguished from charcoal (*le bois de charbon* or *le fusain*) and from lead pencil (*la mine de plomb*)—more closely approximated methods used in painting.[58] Beyond a certain point, according to Jombert, continuing to draw on white paper would lead to a dry and narrow manner that could only be avoided through experiencing the warmth of colored papers and the facility of the black and white chalk media.[59] Only those not destined to paint, such as the sculptor Bouchardon, remained exclusively attached to red chalk; for others, too much of it was a danger and a waste of time.[60]

Drawing chalks were easily available at dry goods or similar stores, where they were sold in blocks. The quality of red chalk varied—later in the century in particular, it seems, the darker and the softer it could be had, the better. It was up to the artist to cut the chalk into long squared sticks that he would insert into his crayon holder (*porte-crayon*; see fig. 8). He either sharpened or rounded the point with a knife to make it

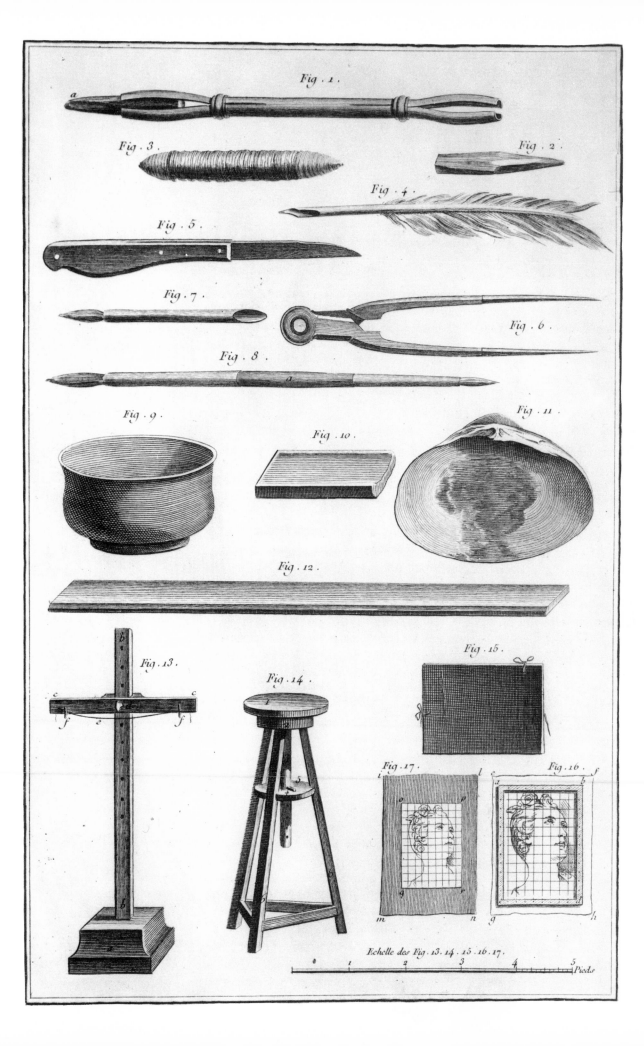

Fig . 1 .

Fig . 3 .

Fig . 2 .

Fig . 4 .

Fig . 5 .

Fig . 7 .

Fig . 6 .

Fig . 8 .

Fig . 9 .

Fig . 10 .

Fig . 11 .

Fig . 12 .

Fig . 13 .

Fig . 14 .

Fig . 15 .

Fig . 17 .

Fig . 16 .

Echelle des Fig .13.14.15.16.17.

1 2 3 4 5
Pieds

ready for use.[61] Some masters allowed their students to sharpen only
once during the entire time alloted to make an *académie*.[62] The student's
first step was to make a slight sketch of the live model in charcoal. This
could be erased easily with a wad of stale bread as it was being gone
over with the chalk to form the definitive contour.[63] While all drawing
manuals recommended this procedure, none gave much detail about the
contour itself, except to require that it be "exact" and "correct." Shad-
ing, however, a more complicated process, was discussed at length.
Three methods were used, the first and second of which were the most
common at the student level: they are hatching, "graining" (*grenant* or
grainant), and stumping.[64] In the first, distinct and separate parallel
strokes were used to shade an area, and, when more shadow was
needed, another set of parallel strokes could be applied over the first to
create crosshatching. In the second method, which we would simply call
regular shading, the chalk was rubbed across the paper surface to form a
solid mass of shade. No individual strokes were necessarily evident; the
grain of the paper, which shows through, is what gave the shadow its
modeling. (This, of course, accounts for the French term *grenant*.) In the
last method, rarer in French drawings but characteristic of the Italian, a
piece of rolled-up paper or leather, called a stump (*une estompe*), was
used to rub and smear the chalk into clear areas of the paper, thus caus-
ing light and dark to melt into each other. Jombert pointed out that red
or other chalk powder could be spread across the paper with the stump
as if it had been applied with a brush. For this, a paper stump was torn
at the end so that it gave the effect of bristles.[65]

It goes without saying that these methods were often mixed. In par-
ticular, hatching was often used on top of regular shading or stumping
to reinforce it. But hatching alone was the least sophisticated and there-
fore the first form of shading from the point of view of instruction, since,
like the technique using red chalk on white paper, it reduced to a very
simple vocabulary—the single stroke, which could be understood as a
kind of module or building block out of which larger units could be con-
structed. It is perhaps for this reason, however, that pure hatching was
to some extent disparaged, especially by Jombert, who associated it
strictly with engraving. He also warned against too much crosshatching,
which he found heavy and in poor taste; and he advised that crossing
not be done at right angles. Used alone, hatching was messy and re-
quired turning the paper in various directions. It was best used, as men-
tioned earlier, to strengthen regular shading, in order to be stumped, or,
as in many drawings, spread with water. The first combination was the
most common; while the second, which dealt in subtle degradations of
tonality, was, like drawings on tinted papers, closer to procedures in oils
and consequently much more advanced.[66] Finally, a necessary finishing
touch for some red chalk *académies* was to wet them from the back and

run them through a counterproofing press in order to eliminate an excess of chalk on the front that might later cause smearing.[67]

In the *Encyclopédie méthodique*, Wâtelet and Levesque claimed that a well-executed *académie* "had as much right to become a precious collector's item as a work of any other category. Both one and the other should be beautiful and faithful images of nature, which ought to serve as models and as concrete representations of the precepts of art, while attesting to the degree of perfection to which art has been brought."[68] The taste for *académies* that had developed among art lovers by the mid-eighteenth century is reflected not just by their appearance in numerous reproductive engravings, but also by their presence—to which sales catalogues bear witness—in many of the foremost collections of the age.[69] By this time, the *académie* had become a genre in itself, much more, at least in spirit if not in fact, than a standardized academic exercise.

At first glance, a collection consisting solely of *académies* done within a one-hundred-twenty-year period in France must seem irremediably homogeneous. Further study, it is hoped, will result in a perception and appreciation of their many subtle differences. In any case, given such a group, it behooves us in the very least to formulate a working hypothesis to describe the evolution of their style. But since *académies* are unique in that they are situated—at least in the eighteenth century—at the very heart of broader developments affecting painting, we should in addition try to use them to speculate on how a mode of seeing developed by the eighteenth-century art school was related to a mode of thinking characteristic of eighteenth-century man.

In spite of the ostensible limitations to the category formed by *académies*, there are still many variables—some of which have already been suggested—that make hypothesizing about stylistic development a treacherous game. We shall restrict ourselves to drawings of the highest quality, and we shall have to ignore the idiosyncracies of individual pieces as well as, for example, the questions of their intended destination or of whether they are the student's or the master's work. Since the present collection is so varied and includes a representative range of quality, too, it could not be on its basis alone that generalizations be founded. Nevertheless, the intention here has been, among others, to articulate the intuitions of connoisseurship that underlie the order in which the exhibition has been presented. It is hoped that a result will be a loose reference scheme for dealing with *académies* in the future.

Basically three chronological and stylistic periods can be distinguished, although this is not without complications. They correspond, not surprisingly, to recognized phases in eighteenth-century art; but rather than being primarily deduced from them, they have their own

stylistic and technical aesthetic, which may in turn ultimately provide us with greater insight into the meaning of the painted styles they underlie. The three periods are, roughly: the 1680s to 1710s, with a transitional period in the 1720s; the 1730s to 1760s; and, overlapping it, the 1760s to 1780s. By the 1790s, and in some cases even earlier, as in the school of David, there emerges a frankly unadorned realism of depiction of the model, which is truly nineteenth century in spirit.

The first period saw the activity of followers of Le Brun, such as Verdier, Jouvenet, and Boullongne. Their figures generally attain a certain rhetorical or physical grandeur conferred by costume, pose, or muscular mass and hardness—the last can be seen in certain drawings by Jouvenet, in which harshness is pushed to the point of being aggressive. The frequent addition of costumes and backgrounds to drawings after life remind us that the noble aspirations of seventeenth-century baroque history painting were still in the minds of these painters; indeed, the heads of certain figures and postures of others deliberately evoke a classical or at least a "stock" repertoire of poses, as can be seen in the work of Le Brun. These figures receive their power through a characteristic technique emphasizing bold contour and hatching. Black chalk or, sometimes in this early period, charcoal are most common on the examples that have come down to us; Boullongne's spectacular drawing in red and white chalks (no. 7) is a glorious exception. Drawings of this period are also frequently on dark papers. Strokes of line are broadened by the use of soft, crumbly materials; moreover, if charcoal was used, it had to be lifted off the paper frequently, and the contour was gone over more than once to attain sufficient darkness. These peculiarities fit in well with the activated, undulating contours used in better drawings by Boullongne (nos. 8 and 9). Jouvenet on the other hand used angular contours or, as in no. 22 especially, exaggeratedly sinewy musculature to energize his figures. The emphasis on hatching that so characterizes this period, to the point where in less successful works it becomes dry and systematic, is less extreme in his drawings.

A transitional group centering around the 1720s is formed by the *académies* of Jean Restout[70] and François Lemoine (no. 26). Black chalk still prevails (see fig. 25) as does hatching, but lighting and modeling are much more complex and febrile than before, since the hatching is greatly softened and stumping has been introduced. The analysis of musculature may still reflect the conventions of Jouvenet, but in its autonomously rippling effects, as in the Restout of no. 28, it anticipates Boucher, who in fact copied Jouvenet *académies*.[71] This style thus combines reminiscences of the late-seventeenth-century group of painters with an increasing "aestheticizing" tendency, which is the principal characteristic of the group of painters who dominate the middle of the century.

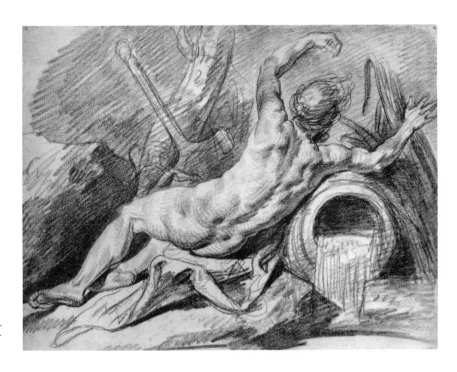

Figure 9. Jean-Baptiste Greuze (1725–1805),
Reclining river god, *red chalk on cream paper.*
New York, Metropolitan Museum of Art, Pur-
chase, 1960, *Joseph Pulitzer Bequest,* 61.1.2.

The second major period (1730s–1760s) includes such names as Edme
Bouchardon, Charles Natoire, François Boucher, and Carle Van Loo.
The most decisive statement of its controlling aesthetic was made by the
sculptor Bouchardon, who was admired by many as the greatest
draftsman of his age and who was particularly well known for his
académies. At their most schematic extreme, his figures reduce to separa-
ble elements of contour, shading, and hatching (nos. 3 and 4). His pref-
erence for the use of red chalk on white paper was shared by many of his
contemporaries, and until about 1770 it appears to have dominated. Rea-
sons for this can only be suggested: it was mentioned earlier that the
technique was often associated with sculptors; insofar as Bouchardon's
contemporaries are concerned, however, their preference for it might
have to do with precisely the kind of clarity that Bouchardon the
draftsman derived from using red chalk. For him, this clarity seemed to
be a goal in itself, which is also reflected, for example, in the *académies* of
Van Loo and sometimes Boucher. The former's emphasis on hatching as
a schematic contrast to contour is the principal element of his *académie*
style (fig. 28); propagated by the crayon-manner reproductions of De-
marteau and Bonnet, Van Loo's influence was felt almost into the
nineteenth century (nos. 1, 30–32, 39). Boucher, on the other hand, and
especially Greuze—whose figure studies provide a transition with the
next group, but who preferred red chalk (fig. 9)—drew much more
freely than Van Loo. In Boucher, however, there always seems to be a

formal emphasis overriding the demands of observation: in his *académies* it is a rhythmic flow of forms created by undulating contours linking unctuous globs of muscle, as in the spectacular *académie* shown in fig. 15.

The tendency in this middle period toward isolation of aesthetic properties, for which the observed model became a mere vehicle, was its most important common denominator, and it ultimately induced the counterreaction of the next generation. Individualization and virtuoso stylishness, when seen in negative terms, became mannerisms that the pre-David generation sought to overcome. The latter, who constitute our third group, comprises painters such as Vincent, Brenet, Berthélemy, and Vien and covers approximately the years from the 1760s through the 1780s. The early work of Jacques-Louis David himself (no. 15) is included in this era. The establishment by the Comte de Caylus of the prize competition for *têtes d'expression*[72] (fig. 5) is symptomatic of the new thrust of this group, in which an inner expressive realism combined with a more realistic representation of observed forms. Expressive subtlety of a more complex and sober kind—in contrast to the often antic, affected, or stereotyped expressions of earlier figures—was frequently suggested by views of the model from the side or from over the shoulder. In matters of technique, an interest in the late baroque examples of the first stylistic group is reflected: drawings in black chalk on tinted papers with white heightening are the rule. Vigorous hatching is often very like that in the first group, but it works differently, since it was used more as a means for close description of the model's anatomy. Moreover— and this is a telltale characteristic—the stump was almost invariably used to soften and generalize the background, against which the figure of the model appears more plastically compact and rounded than in the drawings of the first group. These tendencies are an important step toward the hard, sculptural style of David's *Oath of the Horatii* of 1784.

With the exception of the freewheeling figure studies by Greuze, red chalk *académies* tend to be of lesser quality in this period simply because they are usually student works. It is for these years especially that our earlier generalizations concerning the progress of instruction at the Academy and the uses of certain techniques hold true. Even the anonymous drawing dated 1763 (no. 38), however, through the figure's pose, his partially obscured face, and his seemingly lowered gaze, reveals an emotional inwardness. That this characteristic and its counterpart of greater anatomical realism occurred in a period during which a concerted effort was being made to strengthen the Academy is not surprising. Realism of expression as an antidote to affectation and realism of bodily representation as an antidote to aestheticizing mannerisms are easily understandable, as are stylistic references back to the period of Le Brun and his disciples; for that was the period following the victories of the Academy over the guild and of its consolidation under the ministry

of Colbert. The middle period was one of weakness for the monarchy and for like monolithic institutions; it is thus no surprise to find that, even in Academy drawings, sparkling individual showmanship was the rule. Concomitant with the reinvigoration of the Academy that culminated in Turgot's decrees of 1776 was an increased homogeneity of style. It is this phenomenon, for instance, that at first made our attribution of a striking drawing of the 1770s to David a difficult one (no. 15). When both teachers and students of art see the reinfusion of noble purpose into their national school as a common enterprise, they are more likely to evolve a relatively uniform stylistic vehicle for their aspiration.

If this study is to be of interest beyond the bounds of factual art history or drawing connoisseurship, a few concluding hypotheses concerning the relationship of eighteenth-century seeing to eighteenth-century thought must be attempted. Commenting earlier on the apparent separability of components—hatching, shading, and contour—in drawings by Bouchardon and Van Loo, we learned that this feature was ultimately exploited in their period as an autonomous aesthetic. That the succeeding generation should view this quality as a mannerism tends to confirm the hypothesis, but it might also suggest that, since a mannerism was defined as an exaggeration, there in fact did at one point exist an underlying justification for thinking of the drawing after the life-model in terms of its constitutive vocabulary. On the one hand, it is part of the nature of schooling to encourage this sort of self-consciousness. And it is probably even truer to say that schools that do so flourish in periods dominated by rational thinking. But beyond this, the examination of the vocabulary of Academy drawings, that is, of the conscious result of the most enlightened methods of instruction of their day, has brought us unusually close to the inner operation of thought translated through vision.

A key to understanding this operation lies in the eighteenth-century encyclopedists' own consciousness of the use of convention in art. Drawing was defined by Wâtelet as "the art of imitating with lines."[73] Lines were the constitutive elements of a language that was recognized by Levesque, who continued the *Dictionnaire des beaux-arts* after Wâtelet's death, as a convention in itself. Contour, for example, did not exist in nature but was "a sort of convention of art."[74] One suspects that a result of academic training was to conceive of reality as no more than an assemblage of surfaces that were immediately translatable, thanks to this preconceived schemata, by conventional "signs." The organization or manipulation of elements within the matrix became the artist's principal task. A reality in itself, then, the language of art lent itself to the kind of analysis to which the *philosophes* subjected natural reality, too, and we can view it as the visual counterpart of mental systems or per-

spectives used by experts in other fields to order and contain the reality they studied. Thus, the *Dictionnaire des beaux-arts*, part of the larger *Encyclopédie méthodique*, is a monument to the taxonomania of eighteenth-century rationalism. Its all-inclusiveness and even willingness to embrace conflicting opinions, its view of itself as a compendium of artistic knowledge and doctrine going back a hundred years, are symptoms of a preference for description and classification over critical understanding. One might suggest that a similar divorce between surface and substance is what underlies the mid-eighteenth-century style.

Does this mean that the interests of the succeeding generation, the pre-Davidians, sowed the seeds of romantic rebellion? The answer is yes—but a kind of yes that gives an insight into the historical forces at work. For the interest of the second half of the eighteenth century in the inner life of the individual at first strengthened the need for academic guidance—for the formulas it had always provided as the vocabulary of expressing passions and for the training before the life-model that had always been its version of contact with nature. In this respect, there is indeed a new harmony between the outward forms of style and the inner substance of teaching, and the *académies* of the third group prove it. There was no contradiction, that is, until in a logical next step individuals discovered that the Academy as institution meant the perpetuation of privilege and regimentation—that while encouraging the recognition and study of the individual emotional and physical properties of the model, the Academy did so in such a way that suppressed the individual inclinations of the artist. As one painter, named Jean-Baptiste Robin, who pleaded for new forms of art instruction, wrote, rather than *imposing* its formulas on the artist, it would have sufficed to "teach him principles, or better, to make him discover them himself in nature."[75] Robin cited Roger de Piles' authority for claiming that "the painter's spirit is naturally free: which is to say that it loves [longs for and flourishes in] freedom."[76] The main culprit, that part of the academic program that was most stifling, according to Robin, was life-drawing, for it required a slavish copying of nature including all her flaws; and this seemed in contradiction to the noble correction that was demanded of the history painter.[77] Although he advised the study of antique statuary as an antidote to the deficiencies of the model—and thus we find ourselves at the source of neoclassicism—his implication on a more fundamental level was that the correct and noble achievement of the painter, his ability to create great art, was linked to his ability to be himself, free from academic shackles. He wrote:

> But rarely has the substance [of instruction] penetrated in depth, because a rigid practice has filled up the pores of taste and genius; in a few years time the works of the great man, all looking alike,

appear of no interest, and he fades away leaving behind a man whose talent is of slight distinction.

It is thus that out of the innumerable mass of students that have for fifty years made up the art schools of Europe, there will be barely two whose names will survive with any luster into the following century. And it is worth observing that those chosen few will have become immortal because their style was different from the rest of the school, because, far from the well-beaten paths and less enslaved by conventional opinions, they followed the impulse of their genius.[78]

It was at this point in his article that Robin most severely condemned the system of instruction founded on life-drawing, because, as we recognize from this context, it was primarily what life-drawing connoted as a form and practice of instruction that was offensive. In this sense, then, it was still inescapably associated with hierarchies of eighteenth-century thought that could no longer contain a newly critical and individualizing impulse within its codifying system. The later *académies*, uniform in style yet individualizing in purpose, are unsuspecting metaphors of this revolutionary situation.

So close to the institution that exercised artistic hegemony in the eighteenth century, yet produced by individuals, Academy drawings are a unique visual summary of the interaction between the two. As such, they may be used as a sensitive instrument for interpreting the character of eighteenth-century style, in a way that implies its relationship to general intellectual as well as to purely artistic trends. While it is probably true that the particular contradictions these drawings begin to reveal later in the century were so exacerbated in the 1800s that *académies* ceased to be an indication of much more than a constricting and unvarying routine, we hope a result of the present study is a better awareness of why, on the contrary, academic life-drawings in the eighteenth century were central expressions of the mainstream.

Notes

1. Anatole de Montaiglon, *Mémoires pour servir à l'histoire de l'Académie Royale de Peinture et de Sculpture depuis 1648 jusqu'en 1664*, 2 vols. (Paris, 1853); idem, *Procès-verbaux de l'Académie Royale de Peinture et de Sculpture, 1648–1792*, 10 vols. (Paris, 1875–92); L[udovic] Vitet, *L'Académie Royale de Peinture et de Sculpture, étude historique* (Paris, 1861); and André Fontaine, *Académiciens d'autrefois* (Paris, 1814). These authors were interested primarily in the founding and establishment of the Academy in the seventeenth century. An exhaustive study of its history from about 1715 until its destruction in 1791 has still to be written. For a great deal of useful information about this period, see Louis Courajod, *L'Ecole Royale des Elèves Protégés* (Paris, 1874); and Jean Locquin, *La Peinture d'histoire en France de 1747 à 1785* (Paris, 1912).

2. Nikolaus Pevsner, *Academies of Art: Past and Present* (Cambridge, 1940; reprint ed., 1973).

3. Jacques Thuillier, "Académie et classicisme en France: les débuts de l'Académie Royale de Peinture et de Sculpture (1648–1663)," in Stefano Bottari, ed., *Il Mito del Classicismo nel Seicento* (Florence, 1964), p. 197. Le Brun was twenty-nine; most others were in their thirties.

4. Ibid., p. 191.

5. Ibid., pp. 193–94.

6. See statutes of the Royal Academy of 1648, article IV; reproduced in Montaiglon, *Procès-verbaux*, vol. 1, p. 8.

7. Locquin, *Peinture d'histoire*, p. 72.

8. Thuillier, "Académie et classicisme," p. 199.

9. Vitet, *L'Académie Royale*, pp. 254–56. The statutes of 1663 are reproduced in ibid., pp. 261–71. Granting of the monopoly was the object of article I.

10. In the previous year a decree had forbidden private drawing classes disguised as lessons in mathematics and geometry (see ibid., pp. 252–53).

11. One of the "protected" schools was that of P.-P.-A. Robert de Séry, which was held under the auspices of the Cardinal de Polignac. The example of Robert de Séry was kindly brought to my attention by Pierre Rosenberg; see Henri Bourin, "P. P. A. Robert de Séry," *Revue historique ardennaise*, July-August 1907, pp. 129–93.

12. Courajod, *L'Ecole Royale*, p. 95.

13. See Jean-Jules Guiffrey, ed., *Livrets des expositions de l'Académie de Saint-Luc à Paris* (Paris, 1872); and idem, "Histoire de l'Académie de Saint-Luc," *Archives de l'art français*, 9 (1915), pp. 1–516.

14. See Locquin, *Peinture d'histoire*, pp. 38–40, 56–59. After the suppression of the Académie de Saint-Luc, there were two attempts to hold Salons alternative to those of the Royal Academy. The first was the Salon des Grâces l'Exposition du Colisée, held in 1776 only. The second, founded by one Pahin de la Blancherie, was called the Salon de la Correspondance and existed from 1779 to 1787. See Emile Bellier de la Chavignerie, "Notes pour servir l'histoire de l'Exposition de la Jeunesse," *Revue universelle des arts*, 19 (1864), pp. 38–67 (esp. p. 39). Bellier's lengthy and documented study of the Salon de la Correspondance was published serially as "Les Artistes français du XVIIIème siècle oubliés et dédaignés: Pahin de la Blancherie et le Salon de la Correspondance," *Revue universelle des arts*, 19–21 (1864–65).

15. Locquin, *Peinture d'histoire*, pp. 59–60. On the vicissitudes of this school, see the detailed study by Courajod, *L'Ecole Royale*.

16. The definition of *académie* in the *Encyclopédie méthodique* includes the same categories: "Ce qu'on appelle en langage d'artiste, une *académie*, est l'imitation d'un modèle vivant dessiné, peint, ou modelé. Cette imitation a pour objet d'étudier particulièrement les formes et l'ensemble du corps humain, de s'exercer à ces études, ou de se préparer à quelque ouvrage projeté" (*Encyclopédie méthodique ou par ordre des matières, dictionnaire des beaux-arts* [Paris, 1789–90], s.v. "académie" [hereafter cited as *Encyclopédie méthodique, beaux-arts*]).

17. On nineteenth-century *académies*, see Binghamton, N.Y., State University of New York, exh. cat., *Strictly Academic: Life Drawing in the Nineteenth Century* (1974); and Albert Boime, *The Academy and French Painting in the Nineteenth Century* (New York, 1971), pp. 24–36 and the bibliography contained therein.

18. It would be a worthwhile project to locate as many of these painted *académies* as possible and, after placing them in chronological order, to study their stylistic evolution. Although generally unsigned, they are frequently described in Anatole de Montaiglon and Jean-Jules Guiffrey, eds., *Correspondance des directeurs de l'Académie de France à Rome*, 17 vols. (Paris, 1887–1912); and they should be easier to identify than most academic life-drawings.

19. On these two pictures and the significance of Girodet's conversion of an academic exercise to a history painting, see James Henry Rubin, "Endymion's Dream as a Myth of Romantic Inspiration," *Art Quarterly*, forthcoming.

20. The mid-eighteenth century saw the creation of a plethora of new awards, such as the *prix d'anatomie*, the *prix d'ostéologie*, prizes for drawing hands, heads, and so on, and especially the *prix d'expression* (see fig. 5) founded by the Comte de Caylus. On this and the other prizes, see Emile Dacier, "A propos d'un dessin de Cochin, 'concours pour le prix d'expression,' " *Académie des Beaux-Arts, bulletin semestriel*, 4, no. 8 (1928), pp. 152–66. Beginning in 1684, prizes were limited to the *petits prix*, awarded quarterly by the director, the chancellor, the rectors, and the adjunct rectors, and the *grand prix*, awarded annually since 1663. Preliminary competition for the latter opened a few days before the first Saturday in April; eight finalists were chosen, based on sketches, by the entire body of academicians (Courajod, *L'Ecole Royale*, pp. 7–8). See also note 41, below.

21. Denis Diderot, Jean le Rond d'Alembert, et al., *Encyclopédie, ou dictionnaire raisonné des sciences* (Paris, 1751–65; 2nd ed., Paris, 1782–88), 2nd ed., s.v. "académie de peinture" (my translation). In the *Encyclopédie méthodique, beaux-arts* (s.v. "académie") Wâtelet wrote, "Les *Académies de Peinture* ont pour principal but d'enseigner; ce qui les distingue de la plupart des autres."

22. When overcrowding of the life-drawing class occurred, after the elimination of fees, there was some attempt to weed out poor performers by making the system of evaluation monthly; see Pevsner, *Academies of Art*, p. 97.

23. Charles A. Jombert, *Méthode pour apprendre le dessin* (Paris, 1740; reprint ed. 1755), p. 35 (my translation).

24. See, for example, *Encyclopédie méthodique, beaux-arts*, s.v. "dessein."

25. This was a widespread European phenomenon; see Pevsner, *Academies of Art*, pp. 140–43. For more detail

on French provincial academies, see Locquin, *Peinture d'histoire*, pp. 115–36 and the bibliography in the notes to that chapter. In addition, see Dijon, Musée des Beaux-Arts, exh. cat., *L'Académie de Peinture et Sculpture de Dijon; une école provinciale de dessin au XVIIIe siècle* (1961); Académie des Arts de Lille, *Livrets des salons de Lille (1773–1788), précédés d'un introduction et suivis d'une table de noms* (Paris, 1882); Charles Marionneau, *Les Salons bordelais; ou expositions des beaux-arts à Bordeaux au XVIIIe siècle (1771–1787)* (Bordeaux, 1883); Robert Mesuret, *Les Expositions de l'Académie Royale de Toulouse de 1751 à 1791* (Toulouse, 1972); and Marie-Françoise Pérez, "L'Exposition du 'Salon des Arts' de Lyon en 1786," *Gazette des beaux-arts*, 86 (Sept. 1975), pp. 199–206.

26. The Daniels drawing is reproduced in Cambridge, Mass., Fogg Art Museum, exh. cat., *Drawings from the Daniels Collection* (1968), no. 22.

27. Roger de Piles, *Eléments de la peinture pratique* (Paris, 1776), p. 51 (this is a revised and expanded edition of De Piles' *Premiers Eléments de la peinture pratique*, which was published in 1685).

28. *Encyclopédie méthodique, beaux-arts,* s.v. "dessein."

29. Jombert, *Méthode*, p. 45.

30. Diderot, D'Alembert, et al., *Encyclopédie*, 1st ed., s.v. "dessein" (by Wâtelet).

31. Chardin gave the following account of an artist's training: "On nous met . . . à l'âge de sept ou huit ans, le porte-crayon à la main. Nous commençons à dessiner, d'après l'exemple, des yeux, des bouches, des nez, des oreilles, ensuite des pieds, des mains. Nous avons eu longtemps le dos courbé sur le porte-feuille, lorsqu'on nous place devant l'*Hercule* ou le *Torse*, et vous n'avez pas été témoin des larmes que ce *Satyre*, ce *Gladiateur*, cette *Vénus de Médicis*, cet *Antinoüs* ont fait couler. Soyez sûrs que ces chefs-d'œuvre des artistes grecs n'exciteraient plus la jalousie des maîtres, s'ils avaient été livrés au dépit des élèves. Après avoir séché des journées et passé des nuits à la lampe, devant la nature immobile et inanimée, on nous présente la nature vivante; et tout à coup le travail de toutes les années précédentes semble se réduire à rien: on ne fut pas plus emprunté la première fois qu'on prit le crayon. Il faut apprendre à l'œil à regarder la nature; et combien ne l'ont jamais vue et ne la verront jamais! C'est le supplice de notre vie. On nous a tenu cinq à six ans devant de modèle, lorsqu'on nous livre à notre génie, si nous en avons. Le talent ne se décide pas en un moment. Ce n'est pas au premier essai qu'on a la franchise de s'avouer son incapacité. Combien de tentatives tantôt heureuses, tantôt malheureuses! Des années précieuses se sont écoulées, avant que le jour de dégoût, de lassitude et d'ennui soit venu. L'élève est âgé de dix-neuf à vingt ans, lorsque, la palette lui tombant des mains, il reste sans état, sans ressources et sans mœurs; car d'avoir sans cesse sous les yeux la nature toute nue, être jeune et sage, cela ne se peut" (in Denis Diderot, *Salons*, ed. Jean Seznec and Jean Adhémar [Oxford, 1960], vol. 2, *Salon de 1765*, p. 58).

32. De Piles, *Peinture pratique*, p. 45 (my translation).

33. For example, Francesco Algarotti (*Essai sur la peinture et sur l'Académie de France, établie à Rome* [Paris, 1769], p. 8) stated that from the very first moment he obtained his chalk, the pupil must take care not to copy mediocrities, but "il est à désirer que les premiers profils, les premières mains et les premiers pieds qu'il dessinera soient

d'après les meilleurs maîtres.'' Jombert, however, recommended engravings only when original drawings were unavailable (*Méthode*, p. 39).

34. Pevsner, *Academies of Art*, p. 177.

35. De Piles, *Peinture pratique*, p. 32 (my translation).

36. *Encyclopédie méthodique, beaux-arts*, s.v. ''académie'' (my translation).

37. Pevsner, *Academies of Art*, p. 96.

38. Locquin, *Peinture d'histoire*, p. 78.

39. Montaiglon, *Procès-verbaux*, vol. 7, pp. 6–7.

40. Quoted in Locquin, *Peinture d'histoire*, p. 78 (my translation).

41. The only exception to the rule permitting only male models at the Academy came into existence with the founding in 1759 of the *concours de la tête d'expression* (expressive head competition), which was held once a year and lasted three hours. Obviously, only the model's head was studied. (See also note 20, above.) Lagrenée, however, drew a large number of *académies de femme*, seventeen of which were engraved by Louis Bonnet.

42. Locquin, *Peinture d'histoire*, p. 79.

43. For an explanation of the mistaken inscription, see London, Royal Academy of Arts, exh. cat., *France in the Eighteenth Century* (1968), no. 490.

44. See Montaiglon, *Procès-verbaux*, vol. 4, p. 33.

45. Dacier, ''A propos d'un dessin de Cochin,'' p. 158.

46. Each pose usually lasted three days, unless there was a special competition, in which case the pose might be extended for a week (Montaiglon, *Procès-verbaux*, vol. 3, p. 134).

47. My description of Cochin's engraving is bassed partly on the commentary about it in *Encyclopédie méthodique, beaux-arts*, s.v. ''dessein.''

48. The drawing, whose present whereabouts are unknown, appeared in a sale at the Musée Galliéra, December 7, 1971 (fig. 2). It was kindly brought to my attention by Pierre Rosenberg.

49. Michel-François Dandré-Bardon, *Traité de peinture* (Paris, 1765), vol. 1, pp. 30–44 (article IV).

50. De Piles, *Peinture pratique*; Gérard de Lairesse, *Les Principes du dessin* (Amsterdam, 1719); and Jombert, *Méthode*.

51. Locquin, *Peinture d'histoire*, p. 72.

52. *Encyclopédie méthodique, beaux-arts*, s.v. ''instruction'' and s.v. ''leçon.''

53. Jombert, *Méthode*, pp. 60–61.

54. See De Piles, *Peinture pratique*, p. 40; Jombert, *Méthode*, p. 55; and *Encyclopédie méthodique, beaux-arts*, s.v. ''dessein.'' The last is an expanded version of Wâtelet's article in the original *Encyclopédie* of Diderot, D'Alembert, et al.

55. Jombert, *Méthode*, pp. 54–55.

56. *Encyclopédie méthodique, beaux-arts*, s.v. ''académie.''

57. Jombert, *Méthode*, p. 56.

58. *Encyclopédie méthodique, beaux-arts*, s.v. ''académie.''

59. Jombert, *Méthode*, p. 69.

60. *Encyclopédie méthodique, beaux-arts*, s.v. ''académie.''

61. See Jombert, *Méthode*, pp. 55–56; and *Encyclopédie méthodique, beaux-arts*, s.v. ''dessein.''

62. Jombert, *Méthode*, p. 64.

63. See De Piles, *Peinture pratique*, p. 40; Lairesse, *Principes du dessin*, p. 31; and Jombert, *Méthode*, p. 56.

64. The most detailed account of these techniques is in Jombert, *Méthode*, pp. 62–63. See also *Encyclopédie méthodique beaux-arts*, s.v. ''grenée.'' In printmaking the term *grener* means to stipple.

65. Jombert, *Méthode*, p. 66.

66. *Encyclopédie méthodique, beaux-arts*, s.v. *"académie."*

67. See Jombert, *Méthode*, pp. 67–68.

68. *Encyclopédie méthodique, beaux-arts*, s.v. *"académie"* (my translation).

69. Locquin (*Peinture d'histoire*, p. 73) cites the sales of the Comte de Vence, Baillet de Saint-Jullien (also well known as a writer of Salon reviews), Babault, and Nattier.

70. On Restout, see Rouen, Musée des Beaux-Arts, exh. cat., Pierre Rosenberg and Antoine Schnapper, *Jean Restout* (1970).

71. A drawing of two male nudes in the David Daniels collection (reproduced in Washington, D.C., National Gallery of Art, exh. cat., Regina Shoolman Slatkin, *François Boucher in North American Collections* [1973–74], no. 26) is a copy after the only Jouvenet reproduced in Diderot's *Encyclopédie* (1st ed., s.v. *"dessein,"* pl. xix). It must have been done after the original, since it is the reverse of the engraving. See also Mrs. Slatkin's recent article, "A Note on a Boucher Drawing," *Master Drawings*, no. 3 (1975), pp. 258–60.

72. Although the expressive head was done from life, I have not attempted to give the exercise special treatment here; it has been described by Dacier in "A propos d'un dessin de Cochin."

73. *Encyclopédie méthodique, beaux-arts*, s.v. *"contour"* (my translation).

74. Ibid. (my translation).

75. Ibid., s.v. *"instruction"* (my translation). This article has a strong anti-academic bias.

76. Ibid. (my translation).

77. Ibid.

78. Ibid. (my translation).

Catalogue of the Exhibition

All of the drawings are in the collection of Mathias Polakovits, Paris, who has generously loaned them to Princeton. They are on white or off-white paper, unless otherwise noted. Dimensions are given in millimeters, with height preceding width. The bibliographies are not meant to be exhaustive; rather, only the most important and most recent sources have been cited.

Biographies, bibliographies, and technical descriptions of the drawings are by David Levine. The discussions of the drawings are by James Henry Rubin and David Levine.

Louis-Marin Bonnet

Paris 1736–1793

Bonnet was a printmaker who engraved the work of many of the greatest artists of his day. Not much is known about his life. He began his career in his native city, where he specialized in *sujets galants*. Living for a time in Saint Petersburg, Bonnet worked mainly engraving portraits, including those of Catherine II. He returned to Paris in 1768.

As a youth, Bonnet studied with Jean-Charles François and Gilles Demarteau, who invented crayon-manner engraving, a method devised to reproduce chalk drawings accurately. Bonnet's contribution was to improve upon this process by making imitations of two-color chalk drawings, known as pastel-manner engravings, and his prints became major technical feats. His *Head of Flora*, for instance, utilized a combination of techniques and as many as eight different printings.

The drawing in the exhibition (no. 1) is Louis Bonnet's copy after Carle Van Loo; it was made for transfer to a copper plate. The figure is reproduced in a crayon-manner etching of the same direction as plate 23 of Bonnet's *Suite numéroté de 30 grandes académies*,[1] published in 1772 (fig. 10).[2] The drawing shows many signs of having been wet and run through a roller, particularly in the smears and small folds in the paper due to pressing. Once a counterproof was made on the prepared copper surface, the engraver had merely to go over the design with a roulette in order to imitate the effect of chalk on paper.[3] There is hardly any variance between the drawing and the plate, the main aesthetic difference being the greater schematism of the etching due to the use of a mechanical instrument to reproduce chalk lines drawn by hand. The parallel strokes typical of engravings are already present in our drawing: most notable is the way they follow the shifting volumes of the abdomen. These lines are reproduced in the engraving, but there they are thicker, more regular in width, and more abrupt in their transition to different intensities.

Crayon-manner etching was invented by Jean-Charles François and perfected by Gilles Demarteau, both of whom were given official recognition for their achievement by the Academy in 1757.[4] The technique was primarily used to reproduce red chalk drawings, including many *académies*. Demarteau, in fact, was given permission by the Academy in 1771 to reproduce professors' drawings,[5] including many by Van Loo, who was particularly active as a teacher, having been for many years director of the Ecole Royale des Elèves Protégés. During the 1770s, and after Demarteau's death in 1776, Bonnet engraved many pieces used in academic instruction, most of which were for J. B. Huet's *Cahiers de fragments et de principes de dessin*, of which there were at least eighteen.

J.H.R.

Notes

1. This is the title given by Jacques Hérold to a numbered series produced by Bonnet over a year's time. See Hérold, *Louis-Marin Bonnet*, p. 425 and no. 150.
2. The photograph for fig. 10 was kindly provided by Mademoiselle Marie-Catherine Sahut of the Louvre.
3. A contemporary description of the technique is in *Encyclopédie méthodique ou par ordre des matières, dictionnaire des beaux-arts* (Paris, 1789–90), s.v. "gravure."
4. Arthur M. Hind, *A History of Engraving and Etching* (New York, 1963), pp. 287–88.
5. See Jean Adhémar, *La Gravure originale au XVIIIe siècle* (Paris, 1963), p. 135.

Bibliography

Jacques Hérold. *Louis-Marin Bonnet (1736–1793), catalogue de l'œuvre gravé.* Paris, 1935.

Reclining man resting head on folded
arms

Red chalk. | Inscribed lower right in black chalk:
Boucher; *lower right edge in pencil:* 59½ 42½.
*| Glued to cardboard mount; surface has been
pressed and perhaps wetted, giving an uninten-
tional reddish wash effect in many areas across
the surface; upper left corner cut off; tears along
all four edges; sheet was at one time folded verti-
cally down the center. | 440 x 600 mm.*

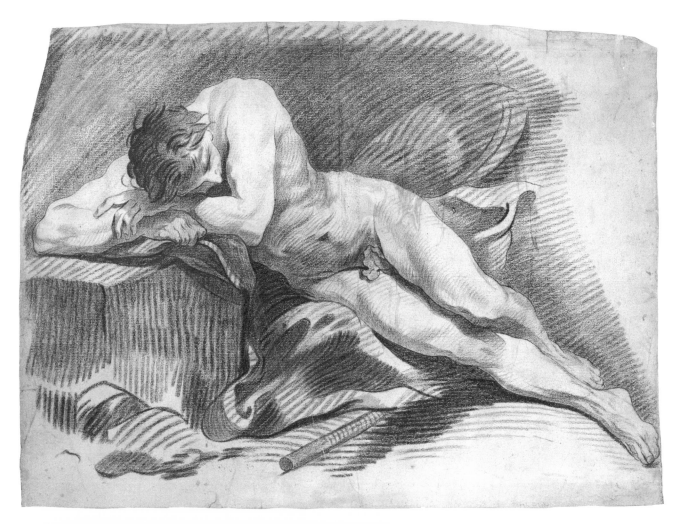

*Figure 10. Bonnet, after Carle Van Loo, Reclin-
ing man resting head on folded arms, red
crayon-manner etching. Paris, Fondation
Jacques Doucet.*

Edme Bouchardon

Chaumont 1698–Paris 1762

Bouchardon was considered by his contemporaries to be the greatest sculptor of his day. As a young man, he received training in Chaumont from his father Jean-Baptiste Bouchardon (1667–1742), and it was during this apprenticeship that Edme produced his first major work, a stone bas-relief at Saint-Etienne de Dijon showing the martyrdom of the saint. In 1722, he arrived in Paris where he studied briefly with Guillaume Coustou *le jeune* before winning the *prix de Rome* in 1723. In Italy, Bouchardon copied Raphael and Domenichino. Between 1726 and 1730, as part of his duties as a *pensionnaire*, he made a free copy of the antique faun in the Barberini Collection to be presented to the king. (The copy is now in the Louvre.) Simultaneously, he was establishing a reputation for doing portrait busts, such as that of Philipp von Stosch (Berlin-Dahlem) completed in 1727. He left Rome in 1732, tempted by the prospect of better commissions in Paris. In 1733, he was *agréé* at the Academy and received permission to lodge at the Louvre, although it was not until ten years later that he produced his definitive reception piece, a marble Christ. In 1747, he rose to the rank of *professeur*, although he never taught at the Academy regularly due to his heavy work load. Bouchardon was also influential in the Académie des Inscriptions et Belles-Lettres, to which he was named in 1737.

Bouchardon's most famous extant work is the Rue de Grenelle fountain, completed in 1745. His adolescent cupid, the *Amour se faisant un arc de la massue d'Hercule* (Louvre), was executed between 1747 and 1750. In 1748, he began his most important commission, the equestrian portrait of the king for the Place Louis xv in Paris, which was completed only after the artist's death. The sculpture was destroyed in 1792, but over four hundred drawings for it remain, mostly at the Louvre.

While Bouchardon's extensive study of human and, for that matter, equine forms locates him at the center of eighteenth-century naturalism, his combination of austere purity and grace places him far from the superficial and decorative aspects of the rococo and make his style the natural antecedent of neoclassicism.

Although he was a sculptor, Bouchardon was in his day and ought still to be today just as much appreciated as a brilliant and prolific draftsman. Moreover, within his graphic oeuvre, *académies* have a prominent, if not nearly dominant place. He drew them all his life, either for themselves or as studies for sculpture projects, and in 1738, indeed, he published an album of engravings called *Livre de diverses figures d'académies dessinées d'après le naturel*. We are fortunate to have four fine examples from his hand, all the more so since they are varied enough to allow for significant discussion of two related problems in Bouchardon connoisseurship, namely, questions of dating and of his stylistic evolution.

No sure system for dating Bouchardon's drawings has yet to be devised based on stylistic criteria, since the evidence of any evolution has always appeared rather slight. He always used red chalk, a technique thought appropriate to sculptors (who never worked in colors),[1] and his miraculously sure manipulation of contour remained a trademark throughout his career. On this characteristic, the Comte de Caylus remarked in his *Vie d'Edme Bouchardon* that "often, without having to repeat or erase, he drew with such confidence that the contour of an entire figure went without interruption from the neck to the heel."[2] Our no. 3 is one of the most outstanding examples of this virtuosity anywhere to be found.

The earliest drawing of our group is clearly no. 2. In its overall style it reflects less Bouchardon's individuality than the general tendencies of the transitional period of about 1725 to 1730 out of which he emerged. That is, in contrast to the crisp and dry line and blanched surfaces we think of as characteristic, this figure exhibits a greater sense of unity deriving from its softer shading, in which parallel hatching is less apparent, and from its less insistent use of the white of the paper. Additionally, Bouchardon's sensitivity to the figure's mood, evoked through the pose as well as through facial expression, is characteristic of earlier artists, such as Jouvenet (see in particular no. 22). Finally, the figure's pose suggests that of a river god, such as those he engraved in his *Recueil de 50 statues antiques dessinées à Rome* of 1732 (fig. 11).

Seated man resting chin on left hand,
seen from side

*Red chalk; border in black ink. | Inscribed lower
right in brown ink over obliterated pencil:
Bouchardon fecit. | Glued to heavy paper
mount; sheet was at one time folded horizontally
across the center. | 397 x 424 mm.*

Figure 11. Bouchardon, River god, *engraving.
Reproduced from* Recueil de 50 statues an-
tiques dessinées à Rome *(Paris, 1732), pl. 47.*

Standing man with right arm raised,
seen from rear

*Red chalk. / Inscribed lower left in brown ink
over partially obliterated pencil: Bouchardon. /
Glued to old cardboard mount; sheet was at one
time folded horizontally across the center. / 582
x 322 mm.*

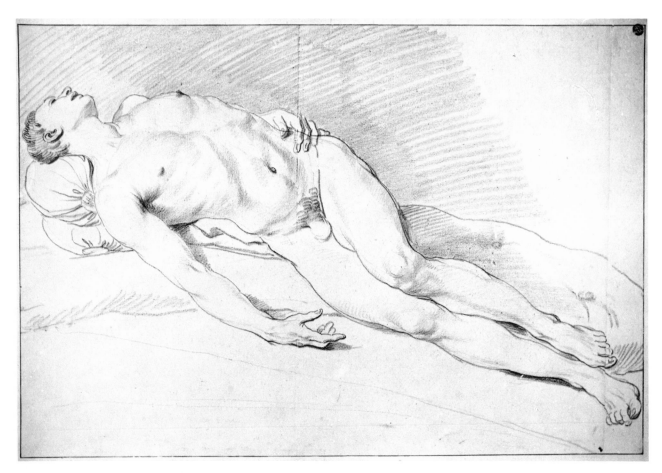

Figure 12. Bouchardon, study for the Plague at
Milan, *red chalk, 1737. Paris, Musée du
Louvre, Cabinet des Dessins, 23905.*

No. 3, on the other hand, can be
compared to an equally brilliant draw-
ing of the same model in an identical
style at the Louvre (fig. 12). The
Louvre drawing is an important
chronological reference point,
moreover, since its relationship to
Bouchardon's relief sculpture for the
chapel of Versailles showing the
Plague at Milan makes it datable to
1737, making our drawing therefore of
similar date.

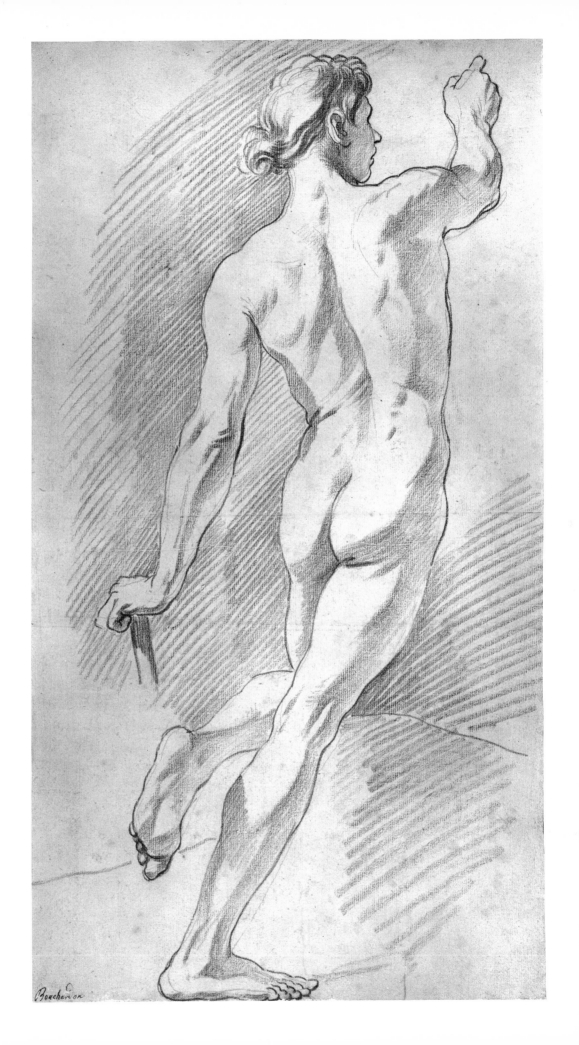

4

Man lying on side, holding a rope with
raised left arm

*Red chalk; border in brown ink. | Inscribed lower
right in brown ink: Bouchardon; farther to
right: 3473. | Glued to heavy paper mount; tears
in upper corners and repair on left edge; sheet
was at one time folded vertically down the cen-
ter. | 410 x 562 mm.*

5 *(opposite)*

Standing man with head turned away,
seen from side

*Red chalk. | Inscribed lower left in brown ink
over partially obliterated inscription in pencil:
Bouchardon. | Mounted on heavy paper; slight
tear in lower left corner; sheet was at one time
folded horizontally across the center. | 600 x
430 mm.*

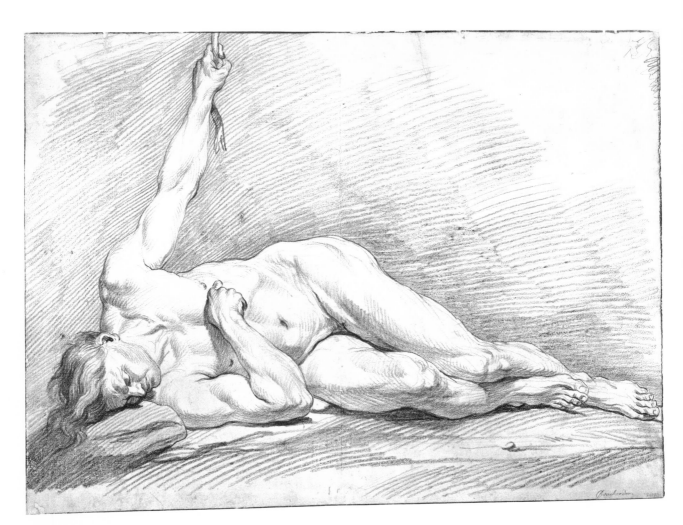

Our third drawing (no. 4) can be
dated to the 1730s on the basis of what
can be derived from markings on its
counterproof, now in Stockholm. The
counterproof, curiously enough, has
been misattributed to Jouvenet on the
basis of a usually reliable old inscrip-
tion by Count Carl Gustaf Tessin.[3] On
a diplomatic mission to Paris from 1739
to 1742, Tessin probably purchased the
counterproof at the so-called
pseudo-Crozat sale in early 1741,[4]
rather than directly from the artist.
The model seems much older than in
no. 3, and his hips seem broad enough
for a woman, although he is definitely
lacking female breasts. Although it is
tempting to suggest a comparison be-
tween this lying figure and those
used, once again, in the relief for the
Versailles chapel, stylistic differences
make a close relationship unlikely.
The drawing has fewer open areas of
white, both in its background and on
the figure itself, and its modeling is
exclusively achieved through parallel
hatching. Furthermore, it is much less
elegant than the figures of 1737, which
bear a morphological resemblance to
certain figures of Lemoine (see fig. 22).
Thus, a comparison between nos. 3 and
4 suggests Bouchardon's transition to
the common but less immediately
pleasing style of no. 5.

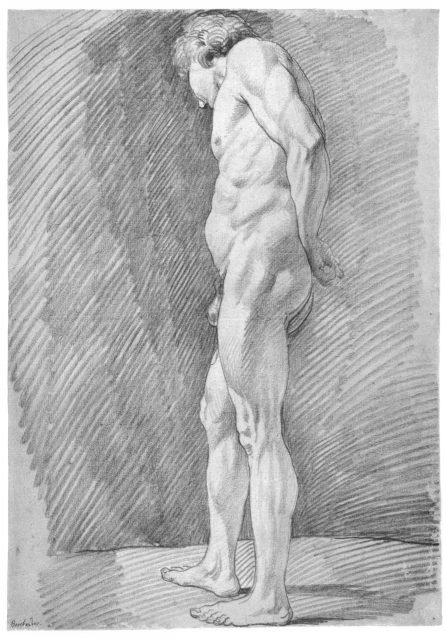

No. 5 is, then, the latest of our draw-
ings according to this analysis. Both its
strength and relative schematism re-
call the studies at the Louvre for
Bouchardon's *Cupid* of 1747 (fig. 13), al-
though, not ostensibly a study for a
statue, no. 5 is less idealized and less
carefully finished.

J.H.R.

Notes

1. See the introductory essay to this
volume.
2. Caylus, *Vie d'Edme Bouchardon*,
quoted in Royal Academy of Arts,
France in the Eighteenth Century (Lon-
don, 1968), p. 47.
3. Per Bjurström, *Drawings in Swedish
Public Collections*, vol. 3, *French Draw-
ings, Eighteenth Century* (Stockholm,
1976).
4. A crossed-out number in the lower
righthand corner of the drawing is
common on items purchased at the
so-called pseudo-Crozat sale.

Bibliography

Anne-Claude-Philippe, Comte de
Caylus. *Vie d'Edme Bouchardon,
sculpteur du roi*. Paris, 1762.

Lise Duclaux. *La Statue équestre de Louis
XV, dessins de Bouchardon sculpteur du
roi dans les collections du Musée du
Louvre*. Paris, 1973.

Alphonse Roserot. *Edme Bouchardon*.
Paris, 1910.

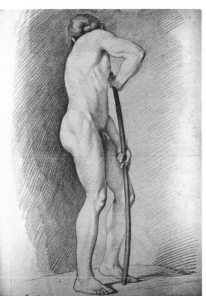

Figure 13. Bouchardon, study for Cupid, *red
chalk, 1747–50. Paris, Musée du Louvre,
Cabinet des Dessins, 24092.*

François Boucher

Paris 1703–1770

To a great extent even today François Boucher's name is synonymous with eighteenth-century art. His long career and prolific output, which included engravings, tapestry designs, wall decorations, and purportedly more than ten thousand drawings, in addition to easel paintings, so spanned and dominated the so-called rococo period that he became a principal target of the reformist polemics of Diderot and later neoclassics.

Boucher's star rose rapidly. After first working in the atelier of his father and then spending a few months under the tutelage of François Lemoine, Boucher began engraving under Laurent Cars. Soon after, from 1721 to 1723, Jean de Julienne employed him to engrave drawings from his collection, notably an important series by Watteau. In 1723, Boucher won the *prix de Rome*, but he did not leave for Rome until 1727, when he was accompanied by his lifelong friend Carle Van Loo. In 1731, he became an *agréé* at the Academy, and he was received as *académicien* three years later on the basis of his *Rinaldo and Armida*, presently at the Louvre. In 1735 he became *adjoint à professeur*, in 1737 *professeur*, in 1752 *adjoint à recteur*, and in 1761 *recteur*. Under the protection of Madame de Pompadour, Boucher finally, at the death of Van Loo in 1765, was named first painter to the king.

It is impossible to give an accurate idea of Boucher's enormous output.

He is most famous for his decorations at Versailles, which respond to the more intimate architectural spaces preferred by the eighteenth century. He also worked for Fontainebleau, the Bibliothèque Royale (now Nationale) and the well-known Hôtel de Soubise (now the Archives). He is also famous for tapestry designs, which he began producing for the Beauvais Manufacture in 1739 with the celebrated Story of Psyche series. Two cartoons, *Sunrise* and *Sunset*, now at the Wallace Collection, London, were commissioned by Madame de Pompadour in 1752. Surely most famous of all are the nine cartoons of *Chinoiseries* presently at Besançon, which were woven to be presented by Louis xv to the Emperor Ch'ien Lung in 1764. These were part of the increasing taste for things oriental in France, a trend Boucher also exemplified by collecting oriental *objets d'art*.

More than any other of his contemporaries, Boucher was responsible for introducing into France, and for satisfying French taste for, scenes derived from Dutch and Flemish genre masters sometimes via Castiglione. The richness and flourish of his coloristic painterly technique had been quickly assimilated from Rubens and Rembrandt, and his decorative manner had sources in the art of Tiepolo, through the intermediary of Lemoine. Boucher's art thus exemplifies a change in French taste from the grandeur of Louis xiv classicism to an intimate and sometimes exotic manner, though as Boucher's male *académies* show, he was capable of creating forms of enormous power.

Our counterproof (no. 6), which is obviously no more than the faint reflection of a magnificent but unknown or

lost drawing, is nevertheless an interesting document. In fact, quite a few red chalk drawings, many *académies* among them, were counterproofed; that is, they were wetted and run through a press together with a second sheet of paper. The second sheet took up the excess chalk to avoid smearing on the first, while it became a unique reproduction, though reversed, of the original. Counterproofs were frequently retouched or reworked by masters so that they could be used nearly as originals themselves. But even unretouched examples, such as no. 6, were considered to have great value in the eighteenth century.

Two groups can be distinguished among Boucher's male *académies*. The first includes only red chalk drawings done primarily, perhaps exclusively, as life-studies and executed mainly in the 1730s. Drawings such as this include, for example, a sheet at the Ecole des Beaux-Arts (fig. 14) and the beautiful studies from the Norbert L. H. Roesler and from the Mr. and Mrs. Gerald Bronfman collections that were exhibited in Washington in 1973–74.[1] The second group of drawings comprises even more spectacular examples, of varying chalk techniques, such as a drawing acquired by the Louvre in 1968,[2] the David Daniels study for Apollo in *The Rising of the Sun* at the Wallace Collection,[3] and the magnifi-

Man seated cross-legged on the ground

Red chalk. / Signature, lower left, in reverse: F. Boucher. / Sheet was at one time folded horizontally across the center. / Watermark: lettering and crowned coat of arms with winged animals, in a circle. / 390 x 275 mm.

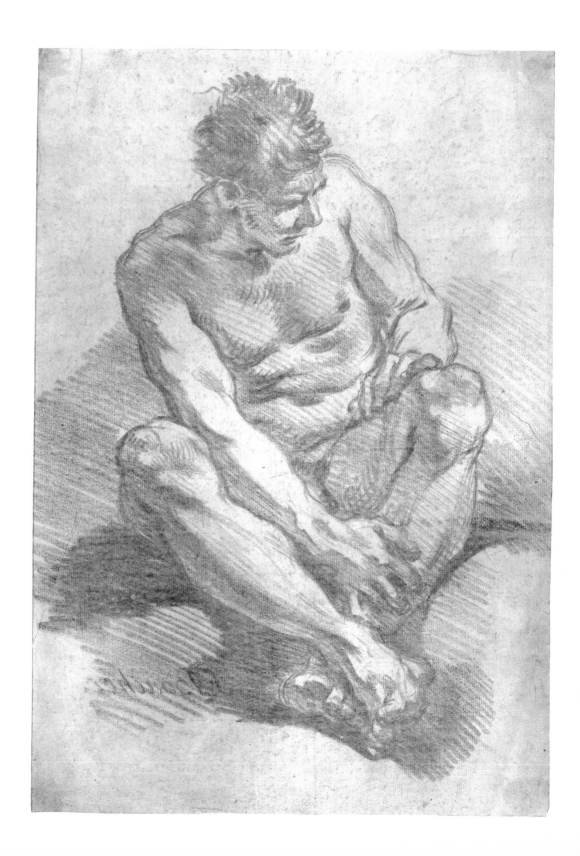

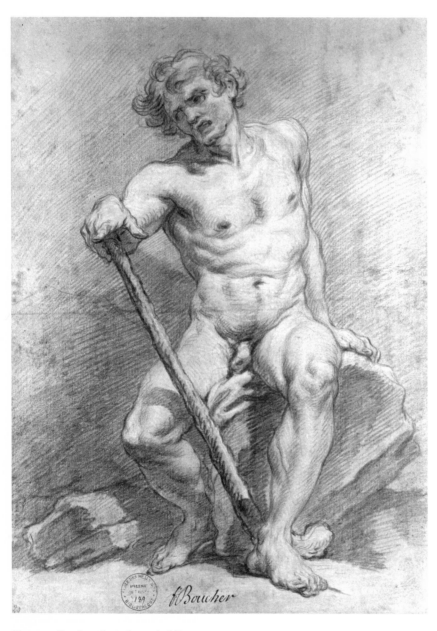

Figure 14. *Boucher,* Seated man holding a
staff, *red chalk. Paris, Ecole des Beaux-Arts.*

cent study for Vulcan owned by Cail-
leux in Paris (fig. 15). Obviously, some
of these drawings were intended for
use outside the studio in one way or
another; and the evidence of a rather
bold signature, discernible in reverse
on our counterproof, suggests that its
original was not a mere workshop
study. But what gives the second
group its real coherence is its even
freer, more fluid stylization of posture
and musculature that endow
Boucher's figures of this group with an
overwhelming sense of energy. The
dynamic directionality and rippling
musculature of the figure of our
counterproof indicates that the origi-
nal belonged to the second group,
which appeared in the 1740s and
1750s. In pose, our figure comes
closest to a figure at Besançon,[4] which
belongs stylistically to the second
group, too.

J.H.R.

Notes

1. Washington, D.C., 1973–74, nos. 24
and 25.
2. Inv. no. RF 31880. Reproduced in
Paris 1971, no. 112, pl. XXII.
3. See Washington, D.C., 1973–74,
no. 68.
4. Inv. no. 2825.

Bibliography

Alexandre Ananoff. *L'Œuvre dessiné de
François Boucher, 1703–1770.* Paris,
1966. Vol. 1.

André Michel. *François Boucher.* Paris,
1906.

Paris, Musée du Louvre. Exh. cat.,
François Boucher, gravures et dessins.
1971.

Washington, D.C., National Gallery of
Art. Exh. cat., Regina Shoolman Slat-
kin, *François Boucher in North American
Collections.* 1973–74.

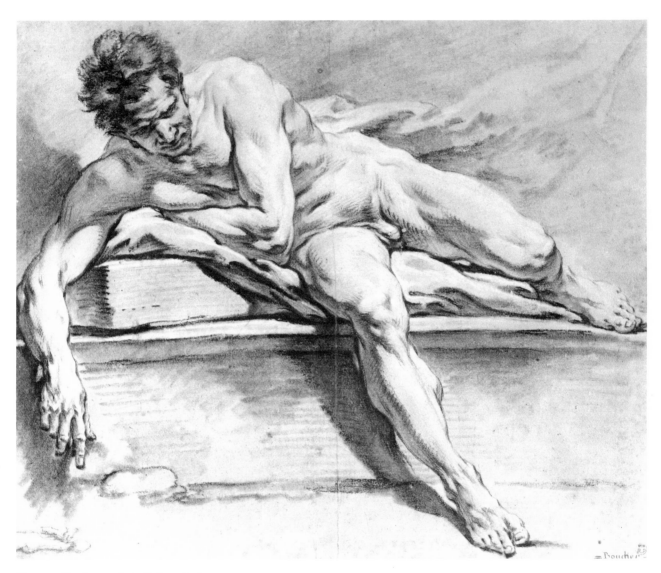

Figure 15. Boucher, study for Vulcan, black, red, and white chalk on buff paper. Paris, Cailleux.

Louis de Boullongne the Younger

Paris 1654–1733

A student of his father Louis de Boullongne *l'ancien* and brother of the painter Bon de Boullongne, Louis *le jeune* won the *grand prix* in 1673. From 1675 to 1680 he was in Rome, where he studied under Charles Errard and copied Raphael compositions for Les Gobelins. Upon his return to Paris, he was assigned by Colbert to decorate apartments at Versailles. Louis was admitted to the Academy in 1681, after presenting *Auguste fermant le Temple de Janus*, and became increasingly influential there. He was named *professeur* in 1694 and elected *directeur* in 1722. In 1725, he succeeded Coypel as *premier peintre du roi*, after having been ennobled in the previous year.

Louis' work was highly regarded throughout his lifetime. He worked for the king at Marly, Trianon, and Fontainebleau, and served the Prince of Condé at Chantilly. In 1702, for the church of the Invalides, Louis provided six paintings dedicated to Saint Augustine. In 1709, he assisted with the ceiling decorations of the chapel at Versailles, for which he also provided an *Annunciation* for the main altar. Although his position in the history of French art has yet to be adequately assessed, this supremely successful artist is generally known for his brilliant draftsmanship and great technical virtuosity.

These sheets were extracted from an album of Louis de Boullongne drawings some years before the album was purchased by Mathias Polakovits, Paris. Not only are there close stylistic similarities between our works and the remaining bound drawings, but the numbers on our sheets correspond to pages missing from the album. Another album of Boullongne drawings, once containing the *Study of a Faun* in Ottawa (National Gallery, inv. no. 0.300) as well as a similar study in the Ashmolean Museum, was dispersed about twenty years ago, according to Pierre Rosenberg.[1]

Most characteristic of Boullongne's aggressive draftsmanship are nos. 7 and 8. In these sheets, the artist's customary use of short parallel hatchings in red or black chalk to plot areas of shade in an orderly, rational manner is particularly bold. Boullongne also used parallel strokes of white to echo their darker counterparts, and thus he created a kind of herringbone effect. Although artists usually use white chalk to give the impression of light glancing off a shiny surface, Boullongne used it equally well as a structural device, contributing to his figures a sense of weightiness and monumentality. Compared to these insistent internal lines, his contours are more hesitant, varying continually in strength and thickness and giving the figures a certain suppleness and flexibility. Very close in style to nos. 7 and

Man kneeling on a pedestal, both
hands holding a support

*Red chalk, heightened with white. | Inscribed
lower right in black ink: 58; verso in black chalk:
obliterated inscription. | Sheet was at one time
folded horizontally across the center. | Water-
mark: bunch of grapes, letters GG beneath. |
542 x 422 mm.*

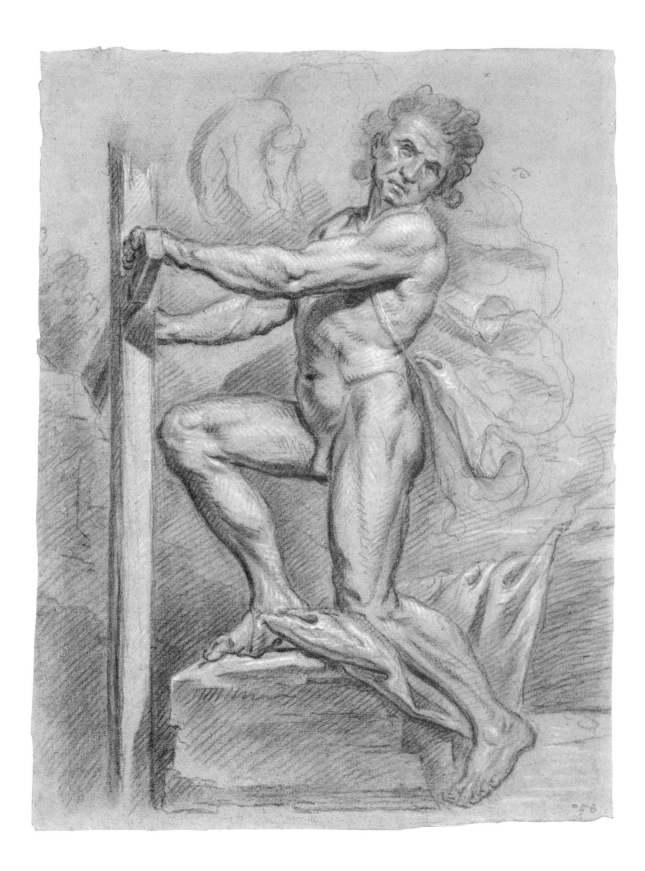

8

Seated man wearing a cap

Verso: seated man with right hand on left shoulder. | Black chalk, stumped, heightened with white, on brownish gray paper. Verso: black chalk. | Inscribed lower left in reddish brown ink: L. De Boullogne; lower right in brown ink: 84. | Tear on lower edge; sheet was at one time folded horizontally across the center. | 543 x 412 mm.

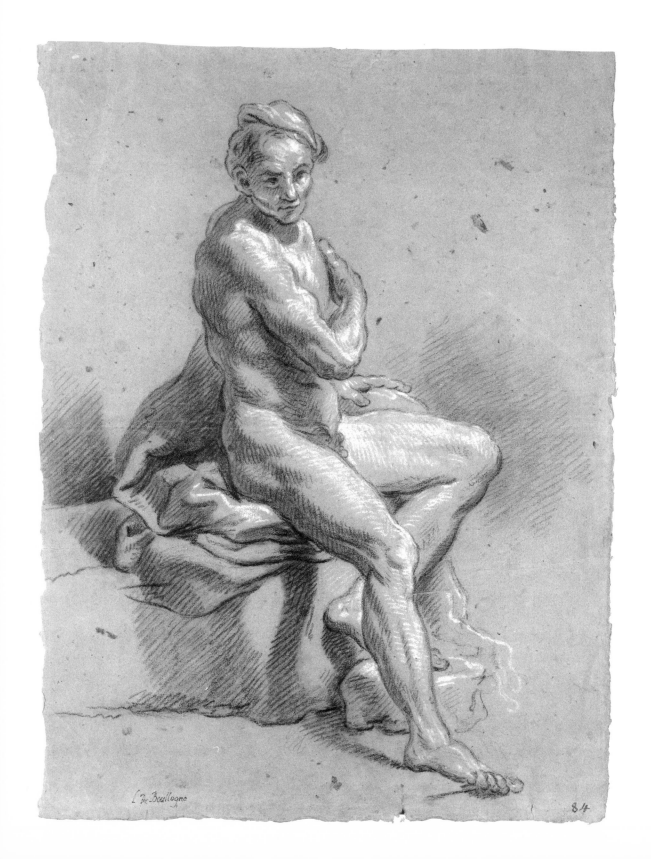

Seated man pointing with left arm,
seen from side

Charcoal, stumped in areas, heightened with
white, on brownish gray paper. | Inscribed lower
left in brown ink, partially cut off: 88 (?). |
Upper left corner torn away; slight tears on bot-
tom edge; sheet was at one time folded horizon-
tally across the center. | 537 x 412 mm.

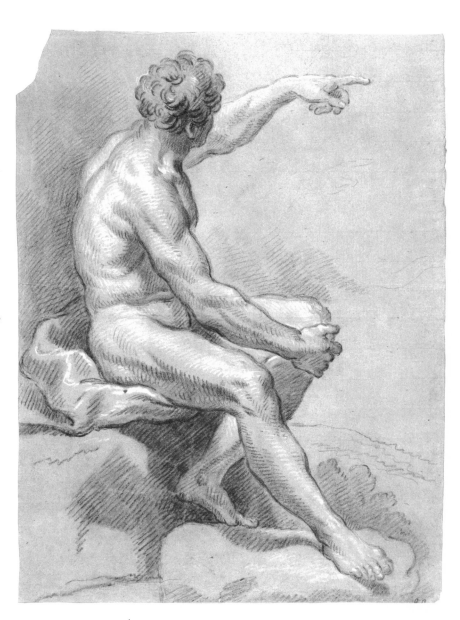

8 is a nude male study, signed and
dated *Louis de Boullogne* [*sic*] 1712, in
the California Palace of the Legion of
Honor, San Francisco,[2] as well as
another sheet, signed and dated *Louis*
Boullongne 1700, in a private collec-
tion.[3]

Two other drawings, nos. 9 and 10,
are somewhat different in style, but
are still in many ways characteristic of
Boullongne. In the seated figure, the
dark parallel hatching seems more
rapidly applied with less sense of
organization and understanding of
anatomy than in the others. The flute
player, least strong of the group, but
clearly related stylistically, lacks much
of the tension between the contours
and the interior shading that gives the
others so much energy. This may be
due, however, to the sheet's less fin-
ished state compared to the others,
and the sheet's relative flatness may
be explained if it has been counter-
proofed.

Our last drawing (no. 11), represent-
ing a Herculean figure lifting a rock,
becomes something of an anomaly in
this group when examined closely. Al-
though the head is typical enough of
Louis, his continuous use of zigzag
shading is much more systematic and
arbitrary than the freer and more sen-
sitive, though still strong and heavy
hatching we think of as characteristic.
This peculiarity leads us to assign it an
earlier date, circa 1680, for example, a
hypothesis that may be supported by
the figure's evocation of Le Brun,
specifically, Le Brun's early painting of
Hercules at Nottingham (fig. 16).
D.L. and J.H.R.

Notes

1. Toronto, Art Gallery of Ontario,
exh. cat., Pierre Rosenberg, *French*
Master Drawings of the 17th and 18th

10

Standing man playing a flute

Red chalk, traces of charcoal visible under the contours, heightened with white, on brownish gray paper. / Inscribed lower right in brown ink: 89; another set of numbers partially cut off; verso in red chalk: Belrolas (?). / Several small tears and folds. / 549 x 425 mm.

11

Man with drapery over right shoulder, carrying a rock

Black chalk, heightened with white, on brownish gray paper. / Inscribed lower right in brown ink: 34. / Tears along bottom edge; lower right corner torn away; water stains on top and bottom edges; sheet was at one time folded horizontally across the center. / 550 x 410 mm.

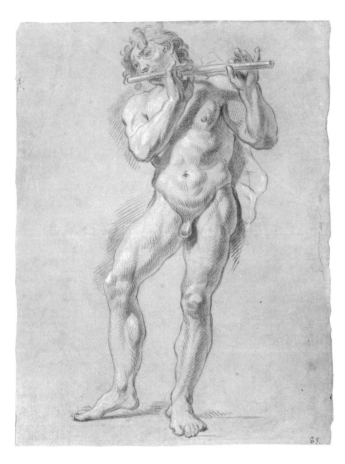

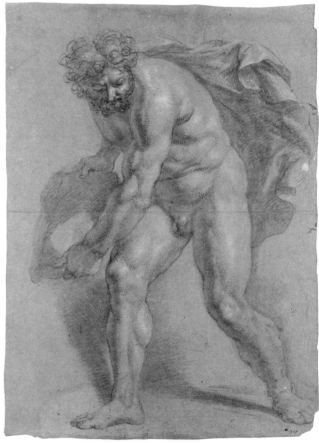

Centuries in North American Collections (1972), p. 140.

2. Inv. no. 1961.8. Reproduced in ibid., pl. 60.

3. See New York, American Federation of Arts, exh. cat., Richard P. Wunder, *Seventeenth- and Eighteenth-Century European Drawings* (1966–67), no. 20.

Bibliography

Amédée Caix de Saint-Aymour. *Une Famille d'artistes et de financiers au XVIIᵉ et XVIIIᵉ siècles: les Boullongne.* Paris, 1919.

Antoine Schnapper. "Esquisses de Louis de Boullongne sur la vie de Saint-Augustin." *Revue de l'art,* 9 (1970), pp. 58–64.

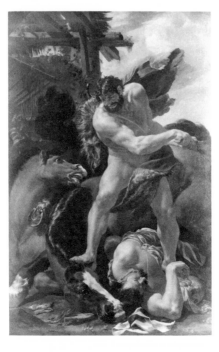

Figure 16. Charles Le Brun (1619–90), Hercules Slaying Diomedes, oil on canvas. Nottingham, Castle Museum and Art Gallery.

Pierre Chasselat

Paris 1753–1814

Seated man resting head on arms, seen from rear

Red chalk, stumped or wetted in areas, heightened with white, on buff paper. / Tears along bottom edge; lower right corner torn away; sheet was at one time folded horizontally across the center. / Watermark: lettering, under which is the date 1779. / 595 x 472 mm.

A student of Joseph-Marie Vien, Pierre Chasselat is known primarily as a miniaturist and was *peintre en miniature des mesdames de France*. Having exhibited two gouaches, *La Surprise* and *Les Regrets inutiles*, in the Paris Salon of 1793, he then entered drawings and miniatures periodically until 1810. Chasselat's earliest known miniature, representing a young lady in a white satin dress, is dated 177(6?). Examples of his work are in the Wallace Collection, London (*Danseuse dans un paysage de théâtre*) and at Montpellier in the Musée Fabre (*Une Femme sortant du bain*). One of his rare portraits, engraved by Charles Damour in 1853, is today in the Louvre. This artist was the father of the history painter Charles-Abraham Chasselat.

This group of drawings is given to Chasselat on the basis of an old inscription. Since they are executed on paper watermarked with the date 1779, we must be dealing with the father, Pierre Chasselat, whose only slightly less obscure son, Charles-Abraham, was born in 1782. The drawings are remarkably strong for a master so completely unknown. Although in red chalk, they exhibit the style characteristic of the 1770s and 1780s, with their fluid treatment of the background and the close-knit and vigorous hatching in short strokes that emphasize anatomical relief. Chas-

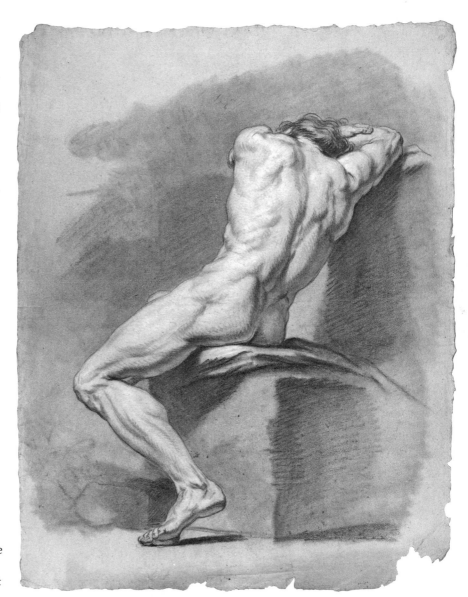

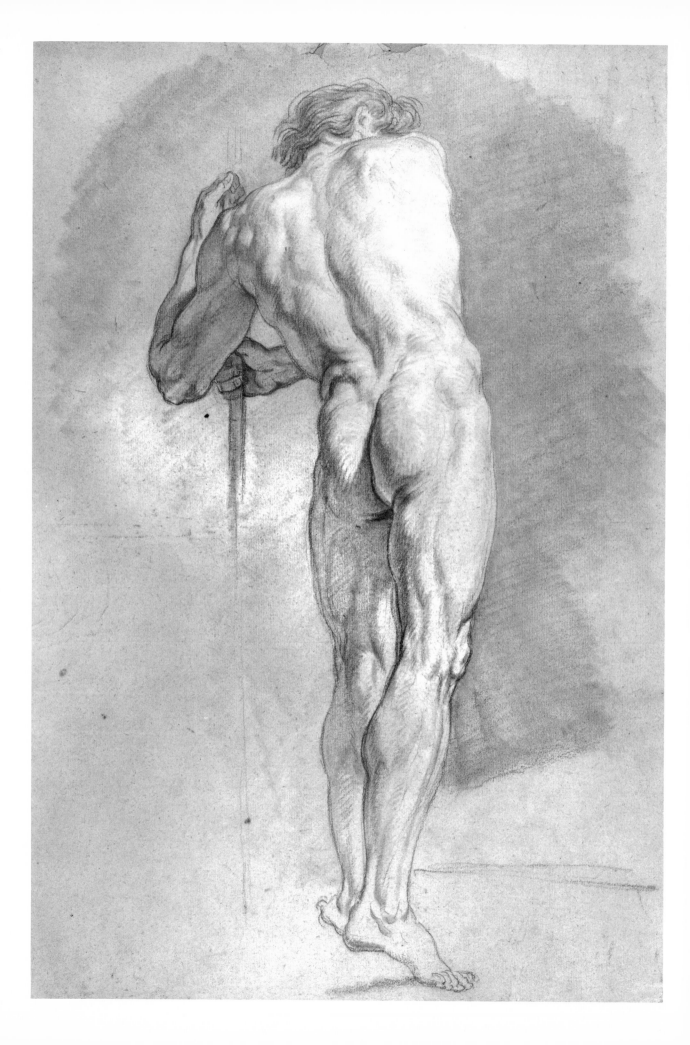

Standing man leaning on a pole, seen
from rear

*Red chalk, stumped or wetted in areas,
heightened with white, on buff paper. / Slight
tear along left edge; sheet was at one time folded
horizontally across the center. / Watermark: let-
tering, under which is the date 1778. / 595 x 480
mm.*

Standing man with right hand held to
left shoulder

*Verso: lightly sketched figure studies. / Red
chalk, stumped or wetted in areas, heightened
with white, on buff paper. Verso: red chalk. /
Watermark: bunch of grapes; lettering, under
which is the date 1779. / 595 x 480 mm.*

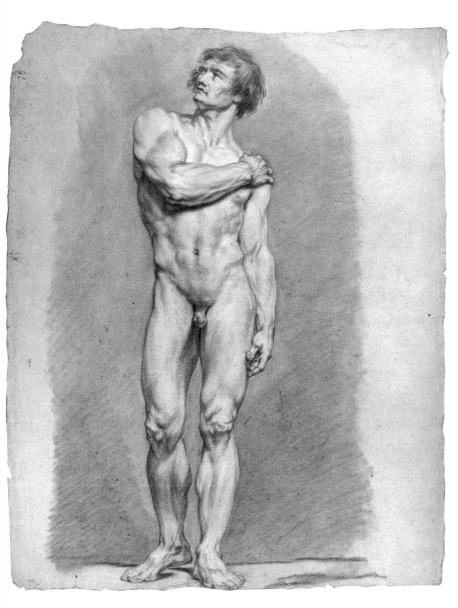

selat's rendering of the muscular ten-
sion in the figure of no. 13 seems espe-
cially successful. No. 14, on the other
hand, seems disproportionately mus-
cled at the right shoulder and biceps.
Nonetheless, this drawing exhibits a
more frank, less conventionalized
realism than any other drawing in this
exhibition. It is no doubt the latest in
date, done circa 1785, while or just
after Chasselat was a student of Vien.
It announces the stark and unadorned
realism of nineteenth-century
académies, which was evolved by stu-
dents of David, the latter himself a
former student of Vien.
J.H.R.

Bibliography

Leo R. Schidlof. *The Miniature in
Europe in the 16th, 17th, 18th, and 19th
Centuries*. Graz, 1964. Vol. 1, p. 142.

Jacques-Louis David

Paris 1748–Brussels 1825

Jacques-Louis David, surely the most dominant artistic force of his time, was largely responsible for reinstituting the spirit of severe classicism into European painting. He began his training in 1769 in the studio of Joseph-Marie Vien. After several years of frustration, he finally won the *grand prix* in 1774 with his *Antiochus et Stratonice*. Stirred by the Bolognese school as well as by the ancient statuary in Rome, he began to establish himself with his *Saint Roch* of 1780 (Marseilles) and his *Bélisaire* of 1781 (Lille).

David reached the height of his artistic power through the role he played in revolutionary politics. His great *Serment des Horaces* of 1784 seemed to later contemporaries to have anticipated the coming struggle. Later, David painted scenes that recorded revolutionary history, such as his *Lepeletier de Saint-Fargeau* (1793, now lost) and the *Marat Assassiné* (1793, Brussels, Musées Royaux des Beaux-Arts). Though David had been received into the Academy in 1783, ten years later it was he who helped bring about its temporary dissolution.

During the Napoleonic period, David distinguished himself as a portraitist, but he was slipping from his unquestioned position of preeminence. When the Bourbon monarchy was restored, he fled to Brussels where, still active, he spent his final years.

Perhaps the most significant discovery in this exhibition is this magnificent sheet that can be given firmly to David on stylistic grounds. Its use of black and white chalks and the prominence of hatching on the figure's body are characteristic of academic drawings of the 1770s, as is even more so the rubbed background, against which the figure's solid, compact volumes stand out so beautifully. In terms of the sureness of its draftsmanship and the intensity of its emotion, however, the drawing far exceeds the works of contemporaries such as Berthélémy, Brenet, Suvée, Taillasson, or Vincent, all of whom are well represented by works in the Ecole des Beaux-Arts in Paris. Oddly enough, there are no known examples of finished academic drawings by David, not even at the Ecole des Beaux-Arts. The closest examples are fragments, one at the Louvre, which was mentioned by Antoine Schnapper in his excellent study of David's painted *académies*,[1] and another at the Musée Eugène Boudin, Honfleur.[2] The latter is the verso of the well-known drawing for David's *Funeral of Patroclus* in Dublin and was therefore probably executed in the second half of the 1770s; both reflect David's Roman experience and the influence of his master, Joseph-Marie Vien. Our drawing, on the other hand, stands out as eminently Parisian: its flowing contours and rippling muscles reflect—in a hardened and masculinized way, of course—the elegant aesthetic of Boucher.

The key piece in our attribution and dating of this drawing is not strictly

Man stepping to right, with head hid-
den in raised arm

Black chalk, stumped or wetted in areas,
heightened with white, on grayish brown paper.
/ Sheet was at one time folded horizontally across
the center. / Watermark: illegible letters. / 545 x
445 mm.

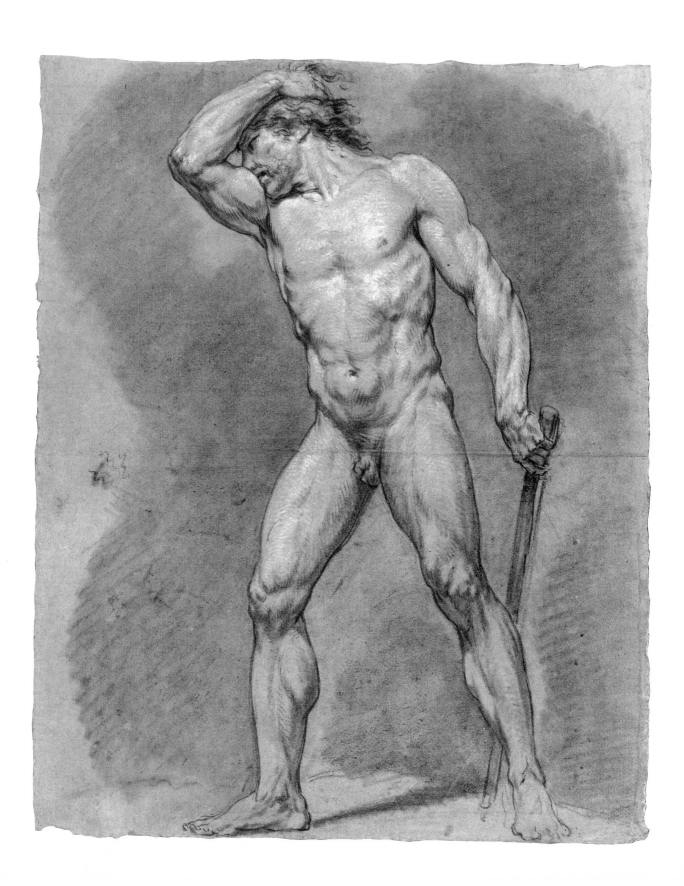

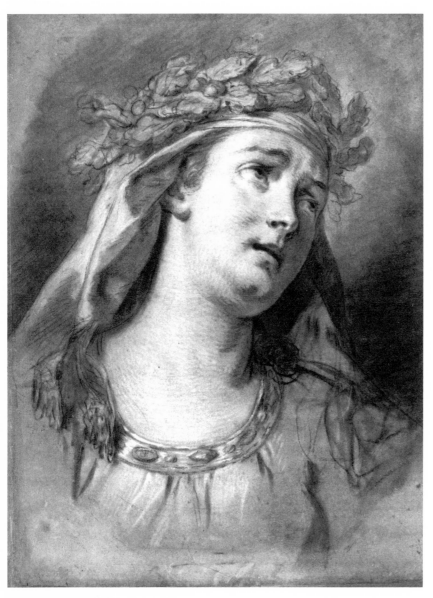

Figure 17. David, La Douleur, *black and colored chalk on brown paper, 1773. Paris, Ecole des Beaux-Arts, 727.*

speaking another *académie* but David's "expressive head" *La Douleur* (fig. 17), a life-study with which he won the *concours de la tête d'expression* in 1773. This splendid drawing, done in black and colored chalks, reveals exactly the same "handwriting" as our piece. The black and white hatching used to model the face and neck are identical to that of the neck and torso of our figure and are unlike that of any of David's contemporaries. Inherited in some sense from Boucher, too, it is further evidence that our drawing predated David's departure for Rome in 1775. Although David is not known for works of such high quality this early in his career, both *La Douleur* and our drawing now bear eloquent testimony to his potential during those years.

J.H.R.

Notes

1. Inv. no. R.F. 4004. See Antoine Schnapper, "Les Académies peintes et le 'Christ en croix' de David," *La Revue du Louvre et des Musées de France*, no. 6 (1974), p. 385, fig. 6.
2. See Pierre Rosenberg, "Disegni francesi dal 1750 al 1825 nelle collezioni del Louvre: il neoclassicismo," *Arte Illustrata*, no. 52 (Feb. 1973), fig. 11, p. 80.

Bibliography

Louis Hautecoeur. *Louis David*. Paris, 1954.
René Verbraeken. *Jacques-Louis David jugé par ses contemporains et par la postérité*. Paris, 1973.

A. J. Deféhrt

born Huring 1723 (?)

16

Seated man with legs crossed, hand on chin

Brownish red chalk. | Inscribed lower right in pencil over obscured writing: Duthér . . . (?). *| Tears on right and left edges; back reinforced with glued strips of paper; sheet was at one time folded horizontally across the center. | Watermark: fleur de lys in a crowned shield, letters* LVC *beneath. | 509 x 428 mm.*

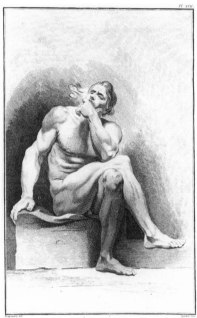

Figure 18. Deféhrt, after Jean-Honoré Fragonard, Figure académique, *engraving. Reproduced from Diderot, D'Alembert, et al.,* Encyclopédie, *1st ed., s.v. "dessein," pl.* XVII.

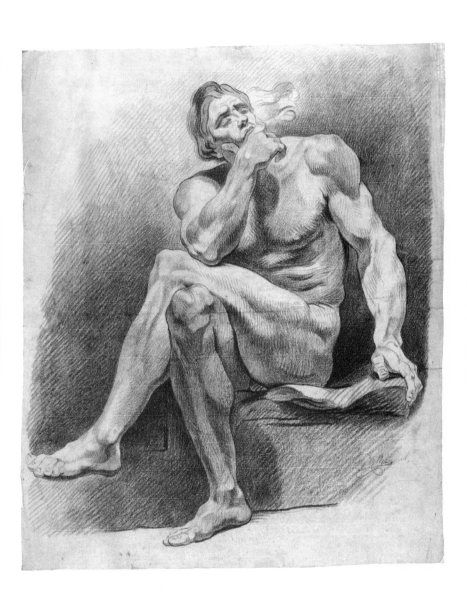

Deféhrt was a printmaker who engraved after some of the most important artists of his day, such as Moreau, Lemoine, Boucher, and Oudry. His name is sometimes spelled deFehrt on his prints and the two initials A. J. are sometimes reversed. Basan, in his *Dictionnaire des graveurs* of 1757, lists a Bertrand de Ferth, born in Huring in 1723, who is believed to be the same person as A. J. Deféhrt.

This drawing is primarily of documentary interest, since it reproduces in reverse the figure from plate XVII of the *Encyclopédie*'s section on drawing (fig. 18). The sheet carries a signature which is probably apocryphal, since it appears to have been applied over another signature. The present one probably gives the name Deféhrt, who is the engraver mentioned at the lower right of the *Encyclopédie* plate. The other name on the plate, however, suggests that the original design was given by Fragonard, although we know nothing of his participation in the project. The name Fragonard may be that under the present signature of our drawing, too. Since the drawing is in reverse and presents many slight differences of detail with the engraved version of the figure, and since in addition it is of relatively high quality, it may very well be that used by the engraver in making the final plate.

J.H.R.

Jean-Baptiste Deshays

Rouen 1729–Paris 1765

Religious painter as well as painter of *sujets galants*, Jean-Baptiste Deshays, also known as Deshays de Colleville and Colleville Deshays, was successively the student of Colin de Vermont, Restout, and Boucher in Paris. In 1751 he won the first *prix de Rome*. The next three years were spent under the tutelage of Van Loo at the Ecole des Elèves Protégés. The young artist departed for Rome in 1754, but little is known of his four-year stay there. In 1759, he was admitted into the Academy and he exhibited at the Salon for the first time that year. His entry included a *Martyre de Saint André* painted for Saint-André in Rouen. Deshays also participated in the Salons of 1761, 1763, and, posthumously, 1765, each time receiving wide acclaim. The Louvre houses his *Achille protégé par Vulcain et Junon*. It was only this artist's early death that prevented him from developing into a truly major figure. He was greatly appreciated by Diderot, who considered him one of the finest painters of his day.

So apparently different in their immediate effects and techniques, these drawings are excellent illustrations of the divergence of style in *académies* within the oeuvre of the same master. No. 18 is a dramatic, aggressively drawn piece, while no. 17 is softer and more lyrical. Though the latter is not signed, a companion of identical style to it currently on the Paris art market bears the same signature as no. 18; in fact, all three were originally discovered together.

No. 17 is undoubtedly the earlier of the two drawings, clearly reflecting the style of Deshays' second master, Jean Restout. Both its technique and style are frankly reminiscent of a drawing such as Restout's fig. 25, which was probably executed in the 1730s. Deshays' drawing, of course, could not be so early, since Deshays was born only in 1729. Rather, it surely dates from the late 1740s, before Deshays moved to the studio of Boucher. The drawing's use of props and its treatment of the background with stumping or washing are key features of Restout's influence, which by this time may be considered somewhat *retarditaire*. Even the model's pose allows a Restout-like treatment of the back and shoulder. Deshays' draftsmanship is only somewhat tighter and clearer. Still, it is far more delicate and subtle than what he will develop under the more "advanced" influence of Boucher evident in no. 18.

Man sleeping against tree, seen from rear

Black chalk, stumped or wetted in areas, some lines reinforced, pencil underdrawing in places. / Glued to paper mount; slight damage at lower right corner; sheet has been rubbed. / 389 x 500 mm.

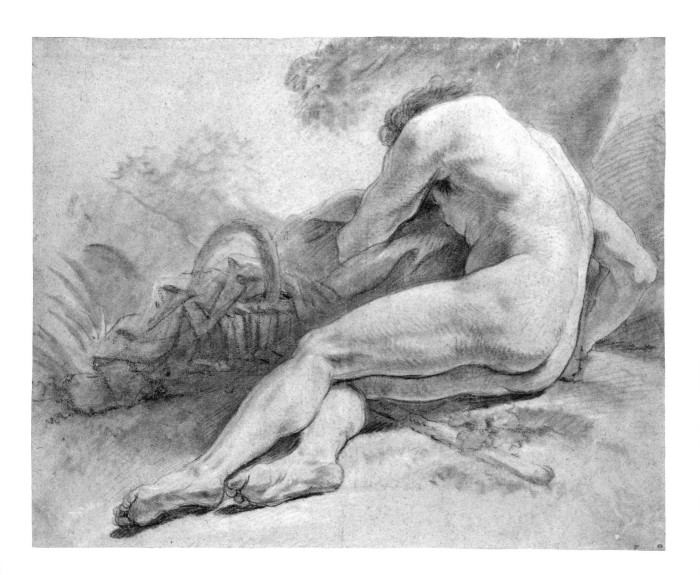

18

Man raising left leg onto platform,
seen from rear

*Verso: nude woman with hands above head. |
Red chalk, charcoal underdrawing for many of
the contours and areas of shadow, heightened
with white. Verso: black chalk. | Inscribed lower
right in black ink: dhays; upper left in pencil:
no. 1251. | Small repair on left edge. | Water-
mark: two series of letters, one below the other. |
312 x 269 mm.*

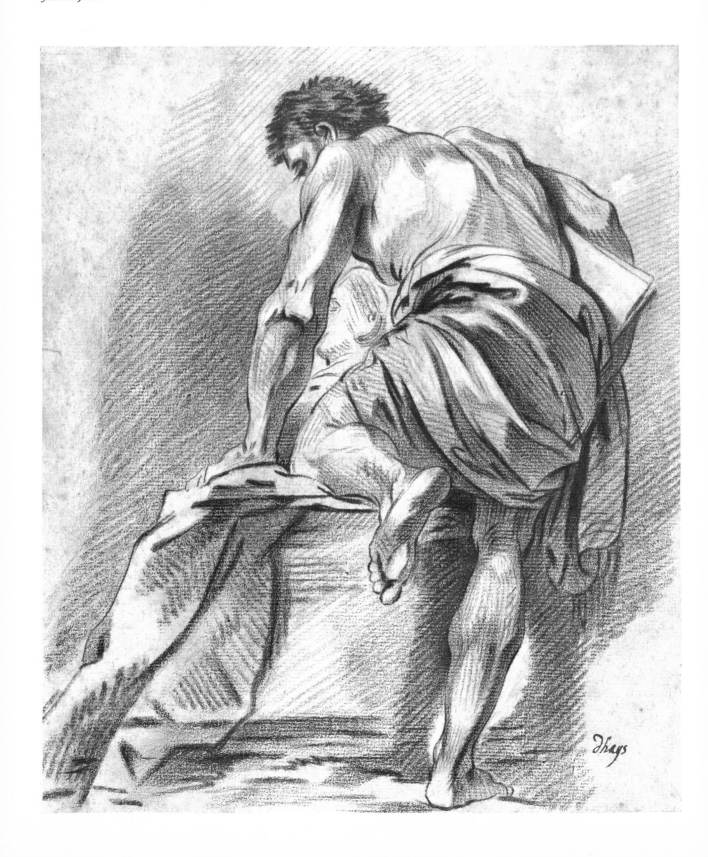

Académies in three chalks are exceed-
ingly rare, and it seems likely that no.
18 is much more than a simple life-
study. The model holds a folder or a
block of large paper under his right
arm, for example, and through the
aperture formed by his left arm, leg,
and body we see what looks like a man
seated in profile. The model's drapery,
which covers part of his body, is even
in a way a contradiction in an *académie*,
the object of which was to study
human anatomy. Finally, the angular
distortion of the figure's back muscles,
as well as of the right knee-joint, seen
from the rear, and the jagged zigzag
strokes used for hair all suggest rapid
observation rather than a student
exercise. On the other hand, the self-
contained sense of the composition
and the presence of studio props
definitely betray a life-study, but a
study of the sort often practiced by
Boucher, who was Deshays' third
master. Indeed, a comparison of no. 18
to Boucher's fig. 15, which was exe-
cuted in or just before 1754, and which
has a similarly bold, though less dry
effect, suggests that our piece was
done in Boucher's studio. Even
Boucher's use of props in fig. 15 is
similar. Although the Boucher was re-
used in a painting (the *Mars and Venus*
of 1754 in the Wallace Collection, Lon-
don), it is not known if Deshays'
figure had a similar destiny.
J.H.R.

Bibliography
Marc Sandoz. "Jean-Baptiste Deshays,
peintre d'histoire (1721 [*sic*]–1765)."
*Bulletin de la Société de l'Histoire de l'Art
Français*, 1958–59, pp. 7–21.

Gabriel-François Doyen

Paris 1726–Saint Petersburg 1806

Doyen, a central figure in French his-
tory painting in the second half of the
eighteenth century, began his training
in the studio of Carle Van Loo when
he was twelve years old. After win-
ning the *prix de Rome* in 1748, he con-
tinued to study under Van Loo at the
Ecole Royale des Elèves Protégés, then
furthered his training at the Académie
de France à Rome, under the direction
of Charles Natoire.

Doyen returned to Paris in 1755 and
was received by the Academy in 1759.
His entry, *La Mort de Virginie*, exhib-
ited at the Salon that year, was heavily
influenced by Domenichino's Saint
Cecilia frescoes at S. Luigi dei Francesi
in Rome. In 1767, Doyen was named
adjoint à professeur after the success of
Saint Geneviève des Ardents for the
church of Saint-Roch. With its coloris-
tic energy, compositional dynamism,
and free handling, the painting shows
the influence of Rubens, evidence of
Doyen's lengthy sojourn in Flanders.
In 1772, the painter completed his
work on the cupola of the chapel of
Saint-Grégoire at Saint-Louis des In-
valides, one of the largest ensembles
of religious painting in the eighteenth
century, which he had taken over after
the death of Van Loo, in 1765. He rose
to *professeur* at the Academy in 1775,
when he was also named *premier
peintre de monsieur*, and became *premier
peintre du compte d'Artois* in 1777. In
1791, the aging Doyen emigrated to
Russia, where he remained professor
at the Academy of Saint Petersburg
until his death sixteen years later.

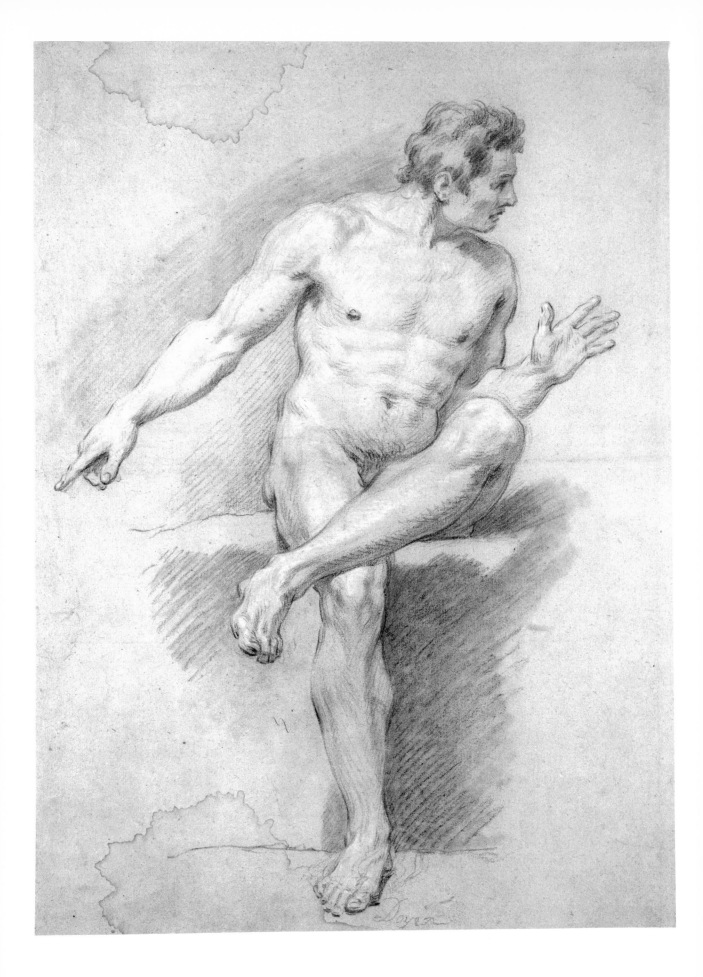

19 *(opposite)*

Seated man looking to left, pointing to right

Black chalk, heightened with white. / Inscribed bottom edge in black chalk: Doyen. */ Water damage on upper and lower edges; sheet was at one time folded horizontally across the center. / 504 x 374 mm.*

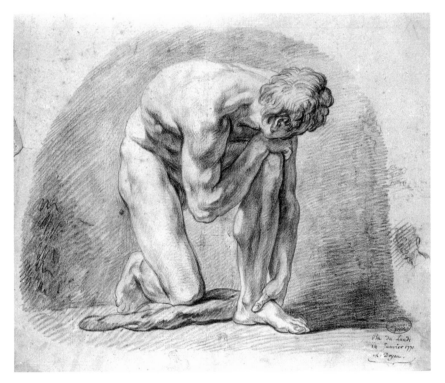

Figure 19. Doyen, Kneeling man, *red chalk, 1771. Paris, Ecole des Beaux-Arts, 859.*

and contrasts that account for so much of our drawing's interest and spirit, effects that are enhanced by Doyen's rapid, zigzag hatching and his quickly undulating and nearly-but-not-quite broken contours. The element of expression, suggesting perhaps surprise or a sudden movement, which is so successfully conveyed in our drawing, is a feature totally absent from Doyen's Beaux-Arts sheet. Our drawing, then, is more likely to have been done in the studio of the painter, either with these aesthetic effects themselves as a goal or with a view to reuse in a larger work. It has little of the finish so often characteristic of the *dessin de professeur*, although its technique in black and white chalks, with a small area of background and shadow washed with water, is characteristic of the 1760s and 1770s. In this case, we should opt for the earlier decade, in which the drawing's elegance and the somewhat artificial nature of its expressive content seem more at home.

Madame Martine Hérold has suggested a spiritual relationship between our drawing and an oilsketch of heads (Musée des Beaux-Arts, Nantes), which she has attributed to Doyen.[2]

J.H.R.

Notes

1. See Martine Hérold, "G. F. Doyen, peintre d'histoire" (thèse de 3e cycle, University of Paris, Sorbonne, 1973), cat. no. 76; and Sandoz, *Gabriel-François Doyen.*
2. Hérold, "G. F. Doyen," cat. no. 60. Madame Hérold was kind enough to share her insights with me both orally and through written correspondence.

Bibliography

Marc Sandoz. *Gabriel-François Doyen, peintre d'histoire (1726–1806).* Paris, 1975.

Until now, the only known life-drawing by Doyen was the one at the Ecole des Beaux-Arts (fig. 19), which carries the inscription *classe du modèle vivant le lundi 14 janvier 1771. M. Doyen.*[1] Comparison with our sheet (no. 19) is instructive for the differences in quality, technique, and purpose they reveal within the oeuvre of a single master. The Beaux-Arts piece is a *dessin de professeur*, that is, a drawing made by the professor during life-class, presumably as an example for his students. It is done in red chalk, the most elementary of the techniques, and it shows little of the freedom and energy of our drawing. Its pose, for example, affords none of the dynamic rhythms

Louis Germain

born Paris 1733

Seated man holding a wooden dowel
with left hand

*Red chalk, traces of charcoal underdrawing. /
Inscribed on mount in black ink:* L. Germain. /
*Glued to heavy paper mount; sheet was at one
time folded horizontally across the center. /* 439
x 299 *mm.*

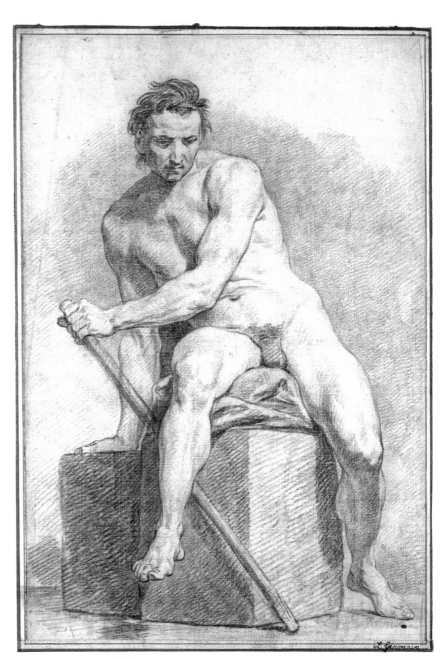

Very little is known about the career of
this artist, who was primarily a
printmaker. He was active by 1757,
engraving the works of the then fa-
mous Dutch Italianate landscapists
Nicoleas Berchem and Bartholomeus
Breenberg, as well as the low-life
scenes of Adriaen van Ostade. During
the Revolution he tried his hand at
more political subjects, such as a
Storming of the Bastille. Germain col-
laborated with Patas on engraving two
paintings after Louis-Gabriel Moreau,
La Cruche casée and *L'Escarpolette.* Sev-
eral of his rare chalk drawings are
known, including a scene of *Fragments
antiques,* signed and dated 1779 (Mas-
son sale, March 19, 1924, no. 65), and a
Vue d'un quai des bords de la Seine
(Georges B. Lasquin sale, June 7–8,
1928).

The basis for identification of this
drawing (no. 20) is the inscription on
the mount, since so little is known
about Germain's artistic activity. The
drawing's style reflects the general
tendencies of the 1750s and 1760s,
when Germain would have most
likely made it. It is a clean and correct
drawing of good quality, with reason-
ably sure contours and skillful model-
ing. Though the head may be a trifle
small for the powerful torso and is not
visibly conceived in relation to the
neck, it has been treated with some
sensitivity to the model's mood. The
figure's posture and undulating con-
tours are slightly reminiscent of the
aesthetic introduced by Boucher, al-
though, of course, Germain lacks in-
dividuality and flair. The drawing's
straightforward unspectacularity
makes it a useful document, however,
showing us of what typical and compe-
tent academic draftsmanship was like
in a period dominated by virtuosos.
J.H.R.

Jean Jouvenet

Rouen 1644–Paris 1717

Jouvenet must be considered one of the key figures in the transition between the art of Charles Le Brun and that of the eighteenth century. Receiving his first training from his father, his precociousness made of him a master in Rouen before he even arrived in Paris at age seventeen. After a time of independence he became a student of Le Brun, and in 1668 he won the *prix de Rome*. Jouvenet never visited Italy, however, but remained in France as a favored assistant of his teacher. His dependence on the styles of Poussin and Le Brun can be seen in the Salon de Mars at Versailles, at which he worked from 1671 to 1674. Despite his competence as a decorator in his early years, Jouvenet also painted religious pictures: as early as 1673 he did a very successful *Christ Healing the Paralytic* for the Mai de Notre-Dame. In 1674 he became an *agréé* of the Academy and in 1681 rose to the rank of *professeur*. In the years 1684 to 1690 he reached full maturity, separating himself somewhat from his earlier style under the influence of Rubens, whose reputation had risen under the persistent efforts of Roger de Piles. Important works of these years include both decorations, such as those in the gallery of the Hôtel de Ville in Toulouse and on the ceilings of the Hôtel Saint-Poulange, as well as religious paintings, such as his *Annunciation* in Rouen. In 1697, he painted one of his greatest works, the intensely powerful *Deposition of Christ*, now in the Louvre. Jouvenet served as director of the Academy from 1705 to 1708. Though his right side became paralyzed in his later years, he remained active, painting with his left hand his final works, such as a *Visitation* for the choir of Notre-Dame de Paris.

In his recent monograph on Jouvenet, Antoine Schnapper has accepted both of our drawings as originals by this master (Schnapper, 196 and 200). The *double académie* (no. 21), an especially difficult exercise, was a favorite of Jouvenet. Other examples of two-figure compositions by his hand are found at the Ecole des Beaux-Arts (Sch. 202; Sch. 203, signed and dated 1687) and in Rouen (fig. 20; Sch. 204). An almost exact duplicate of our drawing, also accepted by Schnapper as original, is housed at the Musée Magnin at Dijon (Sch. 200 bis). Though their chief function was to serve as advanced compositional exercises, Jouvenet's *double académies* also sometimes have narrative overtones, and include props and landscape elements behind the main figures. Our sheet, however, is a pure figure study, and was apparently not made with any specific subject or painting in mind. Since the standing model is the same as in the Rouen drawing, which is signed and dated 1684, our drawing must fall in the same period.

No. 22 is typical of Jouvenet's concern with portraying powerful emotions, which are conveyed by a combination of facial expressions and dramatic poses. Sheets in Lyons (Sch. 199), Sacramento (Sch. 198), and a counterproof in Stockholm (Sch. 214) exhibit a similar interest. This use of the academic life-drawing specifically as a vehicle for the study of emotion did not really become institutionalized until much later in the century. Schnapper notes the existence of a fine replica of our drawing at the Ecole des Beaux-Arts (inv. no. 1129; Sch. 196), which was once in the collection of J. Gigoux (Lugt 1164). The model is the same as in a Restout (fig. 26), which means this drawing was done toward

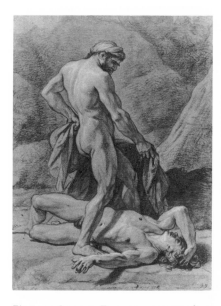

Figure 20. Jouvenet, Two men, one standing over the other, *black and white chalk on buff paper, signed and dated 1684. Rouen, Bibliothèque Municipale.*

the end of Jouvenet's life, probably around 1715, when Restout was his student.

Jouvenet's *académies*, which are relatively numerous, appear to exhibit two different styles. The first, typical of many of the more highly finished *académies* (fig. 20, for example), combines an unctuously flowing contour with a smooth, highly polished, almost slick surface, as in the work of some Flemish artists. These features are the realization of certain qualities latent in the style of Charles Le Brun,

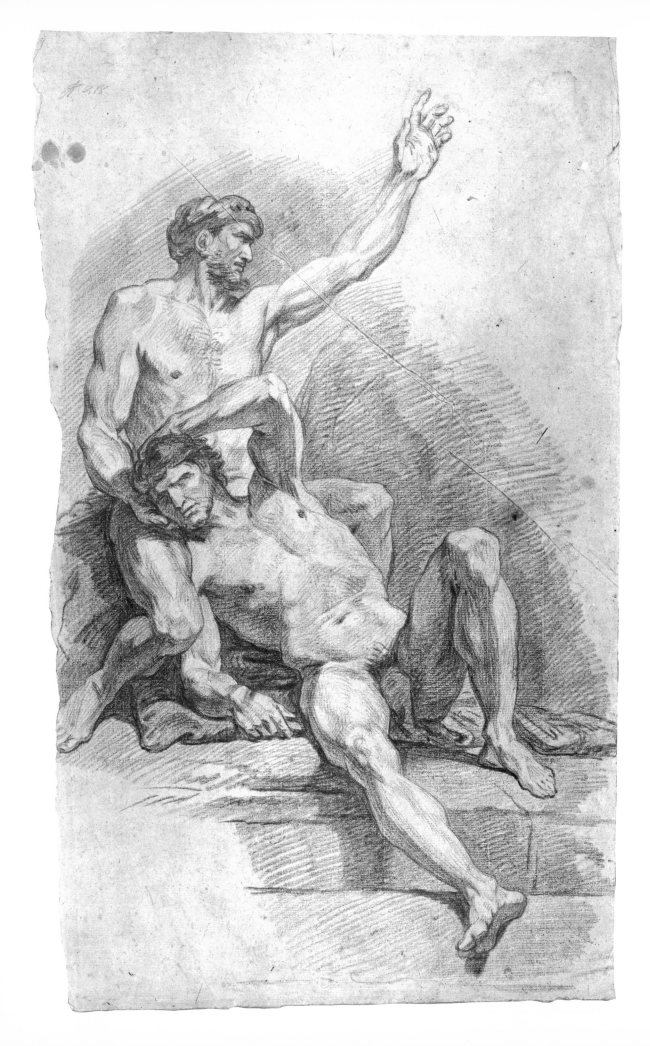

21 *(opposite)*

Two men, one reclining on lap of the other

Verso: face of a woman, lightly drawn near upper left corner. | Red chalk. Verso: black ink. | Inscribed upper left in pencil: A218. | Stains on upper left; diagonal creases; traces of black chalk on surface. | 522 x 308 mm.

22

Seated man leaning head on left arm, seen from side

Red chalk. | Inscribed bottom left in black ink: Jouvenet fct. | Mark of the collection of the Chevalier de Damery (Lugt 2862). | Glued to heavy paper mount; repairs at center of upper edge and along right edge; sheet was at one time folded vertically down the center. | 301 x 340 mm.

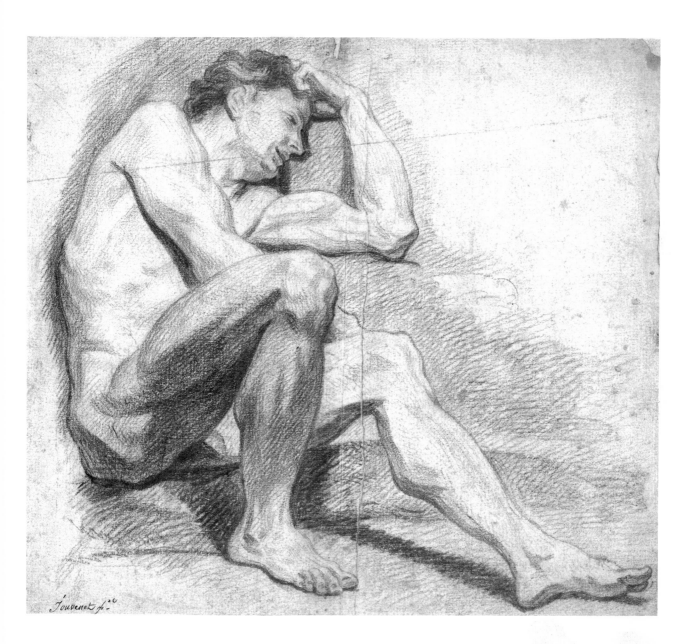

but they look forward in the sense that they clearly reveal the basis of Boucher's interest in Jouvenet. The second style, of which both our drawings are examples, is of less highly finished works. It comprises a more angular treatment of contour and anatomy, with muscles that are sinewy, even stringy, as in no. 21. Since there is evidence that both styles coexist throughout Jouvenet's career, it can be hypothesized that the first style is the result of reworking, smoothing, and finishing drawings that had originally been executed after the life-model, such as ours have been. This process transformed the life-model into a form more closely resembling those more idealized figures Jouvenet used in paintings. The Christ in the foreground of his famous *Deposition*, for example, was surely derived from just such a study.

D.L. and J.H.R.

Bibliography

Antoine Schnapper. *Jean Jouvenet 1646–1717 et la peinture d'histoire à Paris.* Paris, 1974.

Chartres 1629–Paris 1714

Man reclining to right, leaning on
raised left arm

*Verso: figure in crucifixion pose. | Red chalk,
faint traces of white, on buff paper. | Inscribed
verso: Legros 1707. | Repaired at left edge;
stained; a number of other small repairs and
folds; sheet was at one time folded vertically
down the center. | 289 x 542 mm.*

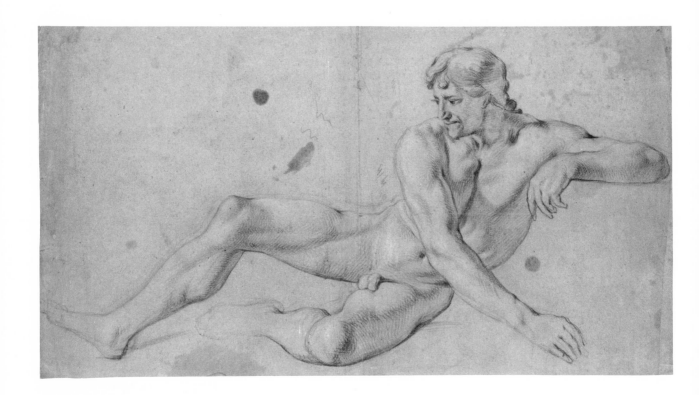

The first in a family of artists, Pierre I
Legros was the father of the portraitist
Jean Legros (1671–1745) and of the
sculptor Pierre II Legros (1666–1719),
the latter of whom spent nearly his en-
tire career in Rome. Pierre the elder
had been the student of Jean Sarrazin.
He was *agréé* at the Academy in 1663
and became *académicien* in 1666 with
his marble *Saint Peter*. He sub-
sequently received the title of sculptor
to the king, and spent most of his time
working on the sculptural decorations
for the park and chateau of Versailles.
He is also known as the author of the
relief showing the *Taking of Limoges* on
the Porte Saint-Martin, and from 1681
to 1682 he worked on the choir screen
of the cathedral of his home town,
Chartres. In 1690 he became *adjoint à
professeur* and then in 1702 *professeur* at
the Academy, where he taught until
his death.

Stylistically, this drawing is charac-
teristic of *académies* done around 1700,
particularly in its use of crosshatching.
It has a dryness sometimes seen in
sculptors' drawings, and the artist's
restriction to red chalk, as opposed to
black, is another general characteristic
of sculptors. The drawing exhibits the
same peculiar flattening of the figure
against the plane of the picture that
also exists in the only other *académie*
known to be by Legros (Paris, Musée
du Louvre, Cabinet des Dessins, inv.
no. 30494). Both are also similar in
technique.

The unfinished left leg, the erased
contour above the right leg, and the
pentimenti around the right heel show
how the artist first established the
general outlines of the figure and then
proceeded to draw him in more detail.
J.H.R.

Paris 1741–1810

Lelu was a history painter as well as an engraver, and was reputed to be a prolific draftsman, although he is little known today. The student of both Doyen and Boucher, he made a trip to Italy in 1761, where he did drawings after Carracci, Domenichino, and Raphael. Upon his return to Paris, he lodged with the Comte Vailard de Saint-Morys and engraved the paintings in his collection. In 1775, Lelu traveled to Spain and Portugal as the attaché to the ambassador of the Marquis de Clermont d'Amboise; he returned to Italy in 1777, and again for a third visit in 1789. He exhibited many works in the Salon of 1793, including a *Mort de Virginie*. Lelu painted the portraits of such notables as Napoleon, Desaix, and Mirabeau. An example of his religious painting is the *Crucifixion* for the church of Saint Jacques du Haut-Pas in Paris.

It is hard to believe that an *académie* in black chalk at the Louvre (fig. 21), which is signed *P. Lelu f. Roma*, 16 *gennaio* 1766, could have been done from life. The dryness of its execution and the over-muscled anatomy of its figure seem rather to reflect the study of statuary and the experience of copying the old masters, by which Lelu is said to have supported himself in Italy. The two red chalk drawings we present here, on the contrary, are less monumentalized and classicizing; they are more suggestive of the naturalistic bias of student training in France, while their brilliant compositional and linear fluidity suggest the influence of Lelu's teachers, Doyen and especially Boucher. The hatchings on the figures' bodies are reminiscent of Boucher, although those that form the background are shorter and less bold than the master's. They are carried over to a degree in Lelu's later Roman piece (fig. 21), and may thus represent a kind of stylistic signature for the artist when working in chalk. Our drawings, remarkable for their spectacular sense of pose and composition and for the artist's quick, confident strokes, convey a greater sense of stylishness than of natural observation of the figure. Even details of muscular relief are reproduced as pleasingly rounded and rhythmed ripples reminiscent of Boucher.

J.H.R.

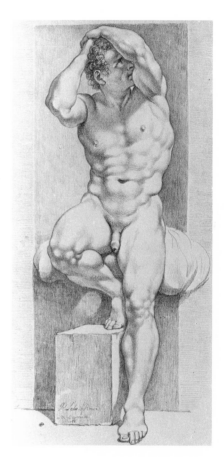

Figure 21. Lelu, Seated man, *black chalk, signed and dated 1766. Paris, Musée du Louvre, Cabinet des Dessins, 30501r.*

24

Man lying on side with left hand over
eyes

*Red chalk. / Inscribed lower right in pencil: P.
Lelu. / Sheet was at one time folded vertically
down the center. / 371 x 536 mm.*

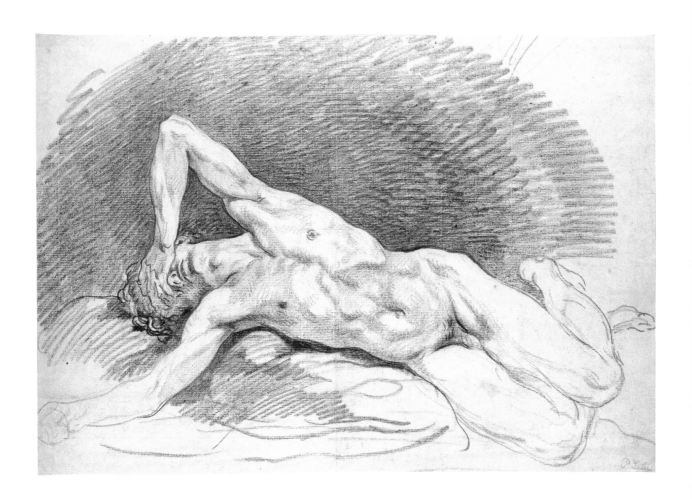

Man lying on chest with left arm be-
hind back

*Red chalk. / Inscribed lower right in pencil: P.
Lelu; above this another inscription has been
erased. / Tears on upper left corner and right
edge; sheet was at one time folded vertically
down the center. / 364 x 535 mm.*

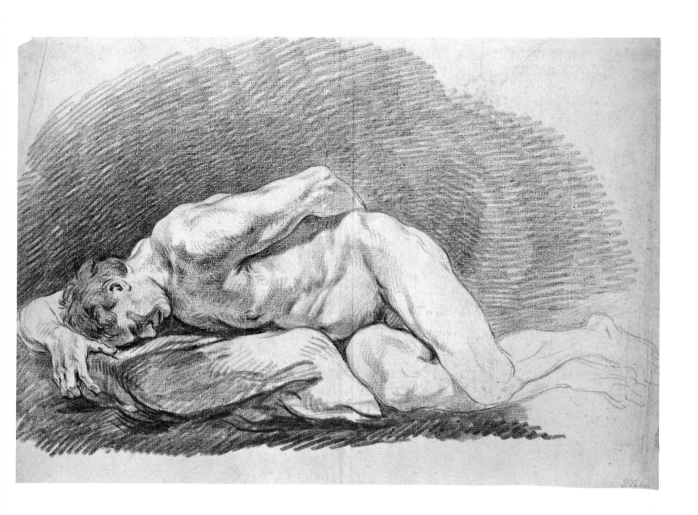

François Lemoine

Paris 1688–1737

His art always refined, elegant, and beautifully finished, Lemoine is a logical precursor of his student Boucher. After studying with Louis Galloche, he received the *grand prix* in 1711 but did not venture to Italy to continue his studies. Upon the submission of his *Hercule et Cacus* in 1718, he was received at the Academy. From an early age, Lemoine intended to be a ceiling decorator on a grand scale, and actually executed a sketch for the ceiling of the Hôtel de la Banque de France (Hôtel de Law) in competition with Antonio Pellegrini. In 1723, he began his *Transfiguration* for the choir of the Jacobin Church (Saint Thomas d'Aquin), but, leaving his work unfinished, he sojourned in Italy for seven months. He stopped in Bologna, Venice, and finally Rome, where he painted his *Hercule et Omphale*, now in the Louvre.

Once back in Paris, Lemoine completed his work for the Jacobins, and then competed in the 1727 *concours*, whose prize he shared with Jean-François de Troy. In the following years, he turned his attention to two major commissions: the *Assumption* fresco for the cupola of the Chapelle de la Vierge in Saint-Sulpice (1731–32), and the huge ceiling in the Salon d'Hercule at Versailles (1733–36). The latter, representing the *Apotheosis of Hercules*, measures eighteen and one half by seventeen meters. Due to the success of this work, he was named *premier peintre du roi*. Lemoine took his own life not long afterwards, however, apparently the victim of paranoia.

Our drawing is a typical example by Lemoine, whose figure drawings and *académies* in black chalk are common. The hesitant contours and patchy modeling are characteristic of Lemoine's sensitive approach, although here they lack the elegance of his more finished studies. The figure's heavy right arm and hand, which is very little modeled, may be the reason Lemoine left this particular piece relatively unfinished. The model is clearly the same as in a drawing at the Louvre (fig. 22),[1] with which our drawing has many other affinities, too. Notice the treatment of the hair, certain areas of modeling, and the summary execution of the extremities of the limbs (compare the Louvre figure's feet to the hands of our figure). Lemoine indeed often leaves parts of his figures unfinished (as in Louvre inv. no. 30529). Our drawing's closest stylistic analogue may be Louvre inv. no. 30547.

Lying figures are common in Lemoine's repertoire, too. In fact, our figure bears a general resemblance to that of Cacus in *Hercule et Cacus* (Paris, Ecole des Beaux-Arts) or to a lying figure in Lemoine's *Tancrede et Clorinde* at Besançon. It is likely that many of Lemoine's so-called *académies* were intended for reuse in larger works, the most famous of which is the ceiling of the Salon d'Hercule at Versailles. Like our piece, such studies are frequently drawn on paper of a smaller format than that generally used for "pure" *académies* (although François Verdier's album of *académies* at the Louvre is a notable exception). Less formal than the academic drawing, then, such studies after the life-model are the common product of a day's work in the studio of the painter.

J.H.R.

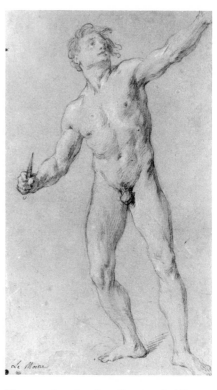

Figure 22. Lemoine, Standing man holding a dagger, *black and white chalk. Paris, Musée du Louvre, Cabinet des Dessins, 30538.*

Note

1. The model bears a resemblance to that in a drawing by Jouvenet (no. 22) and in one by Restout (fig. 26).

Bibliography

Charles Saunier. "Lemoine 1688 à 1737." In Louis Dimier, ed., *Les peintres français du XVIIIème siècle*, Paris and Brussels, 1928, vol. 1, pp. 61–92.

Man lying on back with arms out-
stretched

*Black chalk, slight traces of white heightening
visible but mostly lost due to rubbing or wash-
ing. | Inscribed verso: several illegible numerals
and traces of Lemoine. | Repair at upper right
corner. | 204 x 310 mm.*

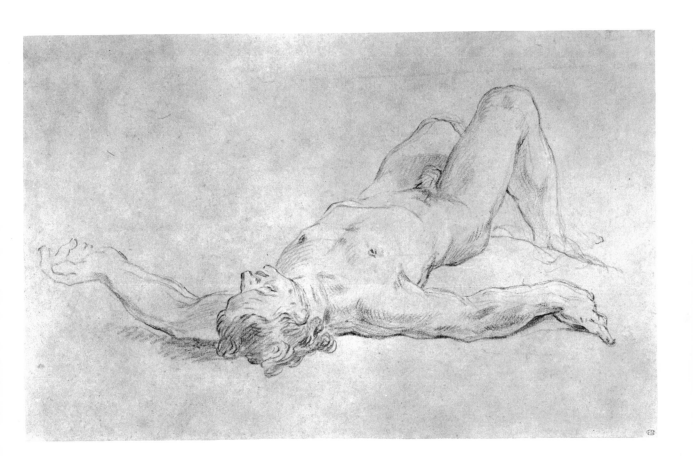

Charles Natoire

Nîmes 1700–Castelgandolfo 1777

Natoire was a versatile artist who is best known for his exquisite landscape drawings and gallant scenes in the manner of Boucher, although he was a major history painter as well. The son of an architect and sculptor at Nîmes, he left for Paris where he became a student of Lemoine. In 1721, he won the *prix de Rome* with a *Sacrifice of Manoah*, and studied in Italy from 1723 to 1729. In 1734, he was received at the Academy with *Venus demandant à Vulcain des armes pour Enée* (Louvre). He rose to *professeur* just three years later.

Natoire furthered his reputation by decorating the oval room of the Hôtel de Soubise with eight scenes from the story of Psyche. He also worked as a designer of tapestries, depicting events from Don Quixote, which were woven at Beauvais, and scenes from the story of Marc Anthony for Les Gobelins. Natoire was also active as a decorator of royal residences, such as Versailles and Marly, where, as before, he worked in a style close to Boucher. Though now considered a lesser light, both Natoire's taste and career in their own day resembled and rivaled those of his contemporary.

In 1751, Natoire returned to Italy to become the director of the Académie de France à Rome, which he headed until 1774. During this period, he decorated the principle vault of S. Luigi dei Francesi, his most ambitious project. In 1774, he retired to Castelgandolfo, where he died a few years later.

Our drawing, which has lost some of its freshness due to rubbing and exposure, is a replica of a drawing at the Louvre (fig. 23). There are slight differences between the two, such as in the small rock in the left foreground, in the drapery on which the model sits, and in the contour separating his left forearm from his right thigh. A major difference, however, is that in the Louvre drawing the model's right hand is cut off just above the fingers by the edge of the paper. In our drawing the hand is fully shown, but its extremity seems to have been added in order to make it so. Finally, the Louvre drawing is heightened in white, while ours shows no traces of having been.

How Natoire got from the Louvre drawing to ours is a subject for speculation. The difference in quality and other clues already cited point to the Louvre drawing as the original but by no means exclude the authenticity of our piece. One suspects that the completion of the model's cut-off right hand is evidence that our drawing began as a counterproof, in which case it would have to be a counterproof of a counterproof, since the original is not reversed. Close examination of our drawing suggests that its contours have been reinforced, whereas its flatness in other areas may confirm this theory. Counterproofs of red chalk drawings are common, especially in the eighteenth century and among *académies*. After all—and this may well have been Natoire's attitude—a professor's life-drawing need not be a unique piece to serve its purpose in instruction.

Many Natoire *académies* are known, especially at the Louvre and at the Musée Atget, Montpellier.[1] They are about equally divided between examples in black and in red chalk. Natoire, who was an active teacher and who headed the Académie de France in Rome for many years, presumably used them in the process of instruction. In 1745, well before he left for Rome, the engravers Pasquier and Huquier published a *Livre d'académies par Charles Natoire*; fig. 24 is a typical illustration from that volume. Its model is the same as in our drawing; his hair is treated similarly, and he is given a setting which, although here more allegorical than natural, is another common feature in Natoire *académies*.
J.H.R.

Note

1. See Paris, Cabinet des Dessins du Musée du Louvre, exh. cat., Lise Duclaux, *Dessins du Musée Atget de Montpellier* (1973). The Ecole des Beaux-Arts also has an example, and Jacques Vilain has kindly told me of another in Brussels.

Bibliography

Ferdinand Boyer. "Catalogue raisonné de l'œuvre de Charles Natoire." *Bulletin de la Société de l'Histoire de l'Art Français*, 1946–49, pp. 31–106.

Jean Claparède. *Les Dessins romains de Charles Natoire*. Montpellier, 1961.

Seated man with legs crossed, head in
profile

*Red chalk. / Inscribed on mount in brown ink:
Natoire. / Glued to old cardboard mount; sur-
face badly rubbed; sheet was at one time folded
horizontally across the center. / 477 x 399 mm.*

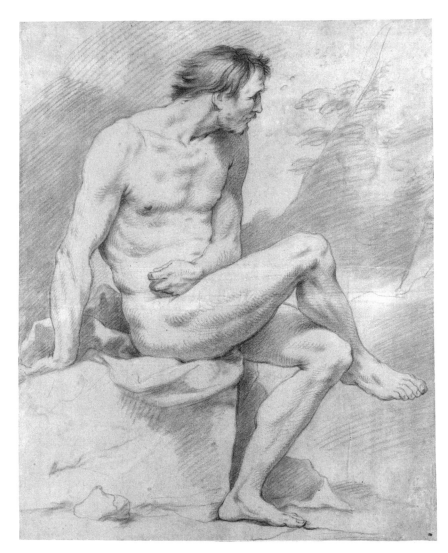

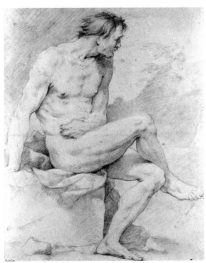

Figure 23. Natoire, Seated man with legs
crossed, head in profile, *red and white chalk.
Paris, Musée du Louvre, Cabinet des Dessins,
31388.*

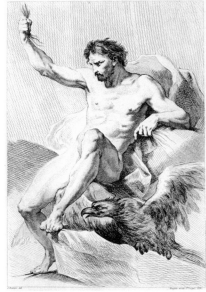

*Figure 24. Jean-Jacques Pasquier (died 1785),
after Natoire,* Seated man and eagle, *engrav-
ing in* Livre d'académies par Charles
Natoire *(Paris, 1745), pl. 8. New York, Met-
ropolitan Museum of Art, gift of J. R. Watkins,
42.16.47.*

Jean Restout

Rouen 1692–Paris 1768

Restout was one of the chief religious painters in Paris toward the mid-eighteenth century. He arrived in Paris in approximately 1707, and became a student of his uncle Jean Jouvenet. In 1717, Restout presented his *Venus demandant à Vulcain des armes pour Enée* to the Academy, and though he won the *grand prix de Rome*, he elected to remain in Paris. Three years later, he became a member of the Academy, rose to *professeur* in 1734, and served as *directeur* from 1760 to 1763; Restout was named *chancelier de l'Académie* in 1761.

Restout was a masterful religious painter, whose grand compositions and elegant figure style bring to mind his Venetian contemporaries. His *Mort de Sainte Scholastique* of 1730 (Tours) is a painting of great dramatic intensity and has rightly been said to be a return to the standards of his uncle Jouvenet. Though his greatest output by far was in history painting, Restout also did some portraits, such as his endearing representation of his artist son Jean-Bernard, dated 1736, in the National Museum at Stockholm.

Though the work of Pierre Rosenberg and Antoine Schnapper has brought numerous Restout life-studies to light,[1] only one in red chalk, other than the drawing shown here, is known to exist.[2] In other respects, however, our sheet is quite typical of Restout's quick hand and softness—although it is not one of his most beautiful works, limited perhaps by the technique used, without any stumping, washing, or heightening. The model's forms, on the other hand, have been treated characteristically. The figure's pose is typical of Restout's preference, with the body leaning over to reveal the shoulder muscles, and Restout seems to have loved to undulate the contour that moves from the neck across the shoulder, down the arm and the side of the body. This treatment, along with that of the thigh and chest, is comparable to that in a beautiful and assured black and white chalk drawing from Stockholm (fig. 25), which was surely done a few years later. The latter also offers a comparison for Restout's telltale foreshortened drawing of the right foot in no. 28.

An early *académie* by Restout[3] still reflects the smooth, liquid feeling of contour in the style of Restout's master, Jouvenet, and it probably predates the 1720s. Our drawing is therefore closer to 1720 or 1725, when a looser style seems to have appeared in Restout's *académies*, while its nearly arbitrary flow of line anticipates later stylistic developments in the art of a draftsman like Boucher.

On the basis of this drawing, finally, we can restore to Restout a red chalk *double académie* at the Louvre (fig. 26), which had been taken from Restout *père* and given to Restout *fils* (Jean-Bernard Restout). That one of the models (the lower one) is the same as in an *académie* by Jouvenet (no. 22), who died in 1717, supports the hypothesis dating this drawing and no. 28 to around 1720, and no later than 1725.

J.H.R.

Notes

1. Rouen 1970, drawing nos. 2–4, 46, 47, and 49.
2. To be published by Pierre Rosenberg and Antoine Schnapper in a forthcoming article in *Master Drawings*.
3. Rouen 1970, drawing no. 2.

Bibliography

Rouen, Musée des Beaux-Arts. Exh. cat., Pierre Rosenberg and Antoine Schnapper, *Jean Restout (1692–1768)*. 1970.

Seated man leaning on a support

Red chalk. / Repairs along left and right edges and in lower right corner; stained in several spots; probably cut down from a larger sheet; considerable rubbing. / Watermark: bunch of grapes with hook, lettering beneath. / 339 x 284 mm.

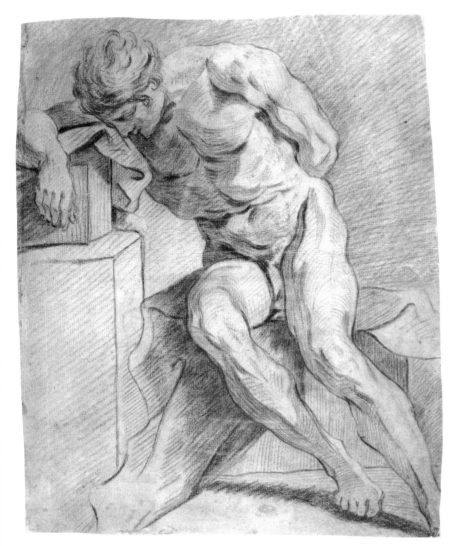

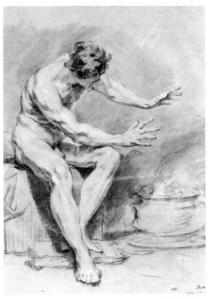

Figure 25. Jean Restout, Seated man with arms outstretched and head turned to left, *black and white chalk. Stockholm, Nationalmuseum, NMH 2972.*

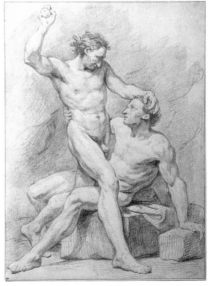

Figure 26. Jean Restout, Two men struggling together, *red chalk. Paris, Musée du Louvre, Cabinet des Dessins, 32716.*

Jean-Bernard Restout

Paris 1732–1797

Jean-Bernard was the student of his father Jean Restout. In 1755, he placed second in the *prix de Rome* competition, and three years later his *Abraham conduisant Isaac au sacrifice* won the *premier grand prix*, enabling him to travel to Rome in that year. He was *agréé* at the Academy in 1765, *académicien* in 1765, and *professeur* in 1771. Jean-Bernard exhibited at the Academy frequently between 1767 and 1791. He apparently took a very active role in the Revolution and in 1793 was appointed president of the Commission of Arts. He argued against academies where admission was based on privilege in favor of open competition among candidates. Examples of his work can be found at the Louvre (*Saint-Bruno priant dans le désert*, signed and dated 1763), Toulouse (*Diogène*), and Tours (*Jupiter chez Philémon et Baucis*).

One of the most beautiful drawings in the exhibition, this sheet is also one of its most interesting discoveries, given its relationship to the Cleveland Museum's *Morpheus* (fig. 27), which is obviously a painted *académie*, and which has been attributed to Jean-Honoré Fragonard. The model is clearly the same in the two works; the poses are closely related, even to the point of being identical for the head, right shoulder, upper arm, and rib cage. Moreover, all the alterations made in the painting have functional explanations: the legs of Morpheus are closed with greater modesty; his right hand and forearm and his left arm have been shifted to hold the floral decoration and attributes. Thus, this drawing is final proof that the Cleveland painting can no longer be ascribed to Fragonard. Moreover, its technique is

typical of *académies* of the late 1750s and 1760s, and I believe it lends support to Pierre Rosenberg's attribution of the Cleveland *Morpheus* to Jean-Bernard Restout,[1] from which, of course, the attribution for this piece has been derived.

Monsieur Rosenberg has suggested that although the *Morpheus* was exhibited at the Salon of 1771 it might have been painted earlier (in the late 1750s no doubt) as an *envoi*, which the *pensionnaires* of the French Academy in Rome were required to execute. Our *académie*, however, is strictly a Parisian work in spirit; that is, it in no way reflects the grander classicism characteristic of the Roman experience. It seems likely, then, that once in Rome Restout used a study that he had executed in or before 1758, the year he traveled to the Villa Medicis as winner of the Rome prize. His hasty return to Paris in about 1760, motivated by the illness of his father, Jean, helps explain the lack of Roman feeling.

These circumstances in themselves lead us to prefer the Restout attribution over another recent hypothesis assigning the Cleveland picture to Noel Hallé.[2] This theory is based on a drawing after the *Morpheus* said to have been made by Gabriel de Saint-Aubin. The sketch is labeled *N. Hallé 1773*. If the sketch is as authentic as it appears—although it is known only through a photograph—Saint-Aubin's attribution to Hallé must be questioned. First of all, nothing in Hallé's publicly exhibited or even catalogued oeuvre corresponds to or suggests the picture,[3] whereas Restout exhibited a *Sommeil, figure d'étude* at the Salon of 1771 of identical dimensions to the Cleveland picture. Second, Hallé was much too old to have been required to send a painted *académie* from Rome. The practice was begun in the 1750s, and he had returned from Rome in

1744. Third, our drawing has little to do with what is known of Hallé's draftsmanly style, while it corresponds to the general *académie* style of the late 1750s and 1760s, when Jean-Bernard is most likely to have been doing such an exercise. Finally, the model is one who appears in the work of Restout *père* (figs. 25 and 26) and is thus not unlikely to have turned up in the work of the son.

Saint-Aubin's mistake, if it is that, can on the other hand be rationalized. First, the *Morpheus* does bear a resemblance to works of Hallé's later style. Second, Hallé was related to the Restouts through marriage: he was Jean's brother-in-law and therefore Jean-Bernard's uncle. The family relationship thus most likely both explains the stylistic similarity as well as Saint-Aubin's confusion.

Even without its connection to the *Morpheus*, our drawing is a fine example of sensitive observation and subtle modeling. Its deft strokes of shading and dramatic pose combine with softer elements to give it a sophisticated and refined strength. Its execution on tinted paper enhances its muted aesthetic, which obviously relates, but stands as an understated complement to the more unabashed aggressiveness of Boucher's *académie* style. We can think of this drawing as standing in a transitional position between the Boucher school and the pre-Davidians, a situation secured by its probable date of execution around 1758. It should be added, however, that its style certainly reflects the influence of Jean-Bernard's father, whose style afforded a transition between the post-Le Brun group and Boucher.

J.H.R.

Man lying on back with arms extended
*Black chalk and charcoal, stumped or wetted in
areas, heightened with white, on grayish green
paper. / Glued to heavy paper mount; lower and
right edges extensively restored. / 332 x 560
mm.*

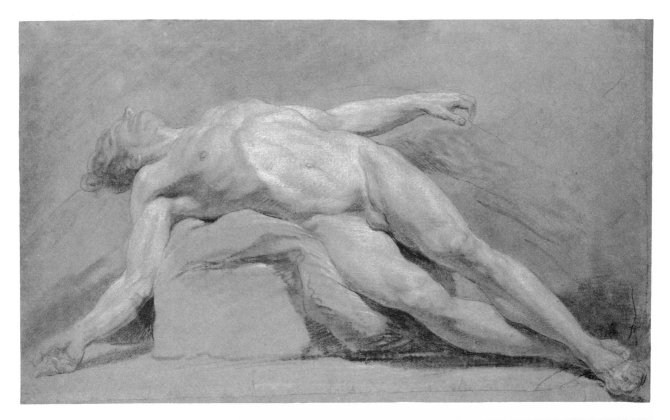

Notes

1. Toledo, Toledo Museum of Art,
exh. cat., Pierre Rosenberg, *The Age of
Louis XV: French Painting* 1710–1774
(1975), p. 86, no. 123.
2. This paragraph reflects information
kindly communicated to me by Anne
Tzeutschler Lurie, Associate Curator
of Paintings, Cleveland Museum of
Art, and by Pierre Rosenberg. Re-
sponsibility for the interpretation I am
publishing, however, is entirely my
own.
3. O. Estournet, "La Famille des
Hallé," *Réunion des Sociétés des Beaux-
Arts des Départements*, 29 (1905), pp.
71–236.

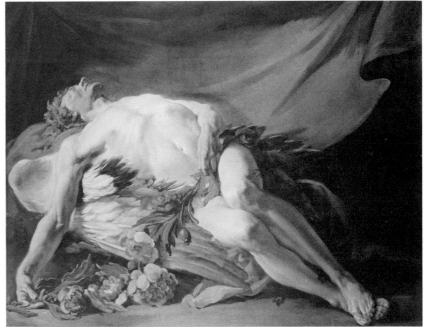

*Figure 27. Jean-Bernard Restout, attributed to,
Morpheus, oil on canvas. Cleveland Museum
of Art, Purchase, Leonard C. Hanna, Jr., Be-
quest, 63.502.*

Louis-Roland Trinquesse

ca. 1745–ca. 1800

The origins of this artist remain uncertain. Pierre Quarré has suggested that Trinquesse came from Burgundy of the Franche-Comté, where the family name appears on various eighteenth-century documents. The latest evidence shows that his father was also a painter and may have trained with Largillière. Trinquesse's birthdate is also unknown; he was probably born around 1745 since he was a student at the Academy in 1770. In that year his name was cited twice in the *Procès-verbaux* for receiving two *médailles de quartier*. The journal of the engraver Wille, as paraphrased by Bellier de la Chavignerie, reports that the artist was later rejected in two attempts at entering the Academy, and that he failed to make a third attempt because he feared final rejection. Trinquesse exhibited at the Salon only in 1791 and 1793, years during which nonmembers were allowed to contribute. Denied access before that, he exhibited frequently at the Salon de la Correspondance. Much of his work was portraiture, but he took some of his themes from literature as well, such as *Le Premier Baiser de l'amour*, exhibited in 1787, which was inspired by *La Nouvelle Héloise*. His last dated works are portrait drawings from 1797.

Our drawings are characterized by their extremely sharp definition of contour and their cool tonality, highly reminiscent of Bouchardon, though their surfaces seem even more metallic than his. The artist seems to have been particularly concerned with exhibiting mastery of his anatomy lessons, for details of the body structure are predominant over any fluid rendering of the whole. This is especially evident in no. 32, which looks almost like an *écorché*, or in no. 30, in which veins stand out prominently on the arm, and where the joint of the knee is so vividly described that the skin seems almost transparent. The reclining figure (no. 31) is somewhat different in emphasis, the calmly rippling muscles of the back beautifully harmonizing with the quiet meditative pose of the figure. In this instance, the super-realistic attention to detail is somewhat muted.

Our attribution of these drawings to Trinquesse is based entirely on stylistic grounds. Although he probably did very few academic studies of this type, many of the stylistic trademarks of our drawings can be found in the charmingly drawn portraits of fashionable women and others, for which he is now best known. In *L'Invité*[1] there is a close kinship with our studies in the clear, crisp overall appearance, the simplified, elegant rendering of the skin, the idealized and somewhat vacuous emotional state of the subjects. In all cases, Trinquesse sets off his figures against a background of evenly applied diagonal strokes of differing intensities. The same way of depicting hair, that is, with a relatively small number of heavy, curving lines to give the impression of light reflecting off thick curls, is in his *Woman Seated with a Plumed Hat*. Similar treatment is seen

Standing man, looking to left

*Red chalk. / Watermark: bunch of grapes, letter-
ing. / 612 x 458 mm.*

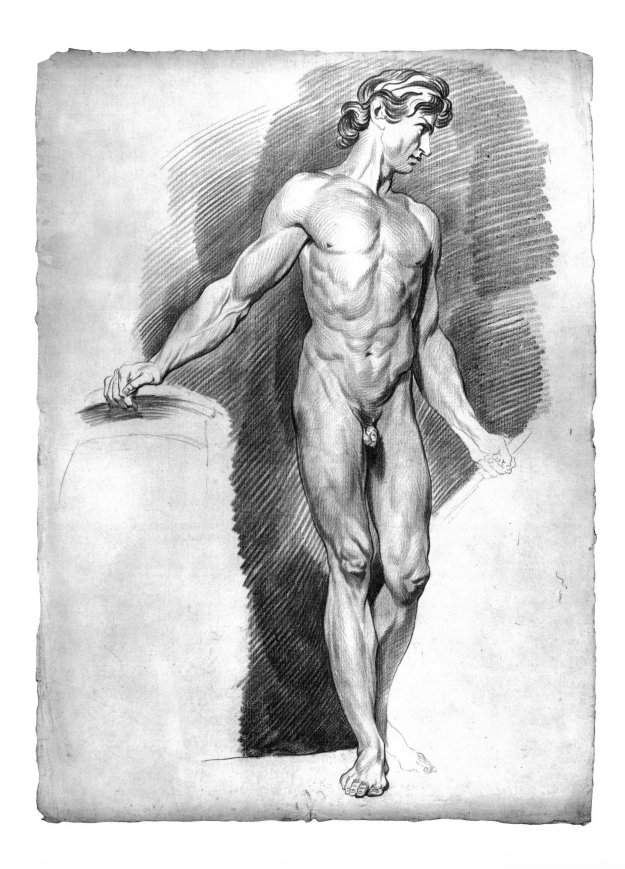

Reclining man leaning on a support,
seen from rear

*Red chalk. / Surface has been wetted or rubbed,
causing orange streaks; perhaps counterproofed
and then reinforced by going over contours;
sheet was at one time folded vertically down the
center. / Watermark: bunch of grapes, lettering. /
451 x 600 mm.*

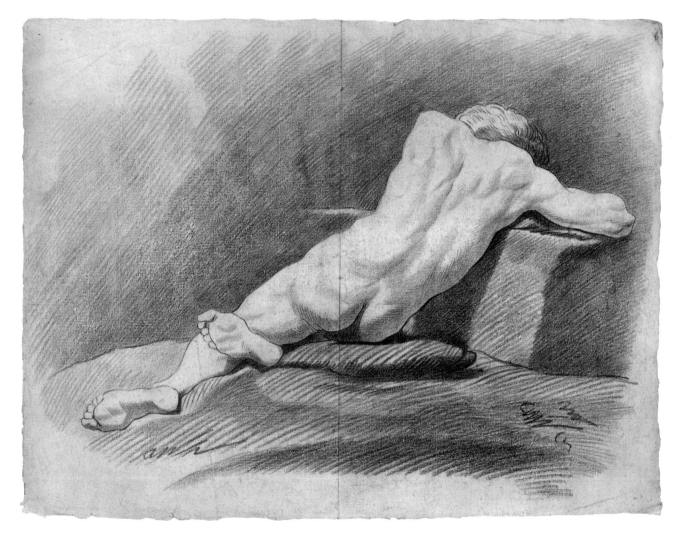

in his *Portrait of the Painter Guérin*,[2]
too, where the face is also modeled
with the same precise but soft concen-
trically curving lines that describe the
flesh in his academic studies. This
technique undoubtedly reflects proce-
dures used by engravers. Another
stylish trademark, as in one of the feet
and hands of no. 30, is Trinquesse's
tendency to leave extremities of limbs
and other small areas of his drawings
unmodeled.

D.L.

Notes

1. Dated September 9, 1775; collection
of Alexandre Ananoff. Reproduced in
Dijon 1969, no. 7.
2. Dijon 1969, no. 66.

Bibliography

Jean Cailleux. "The Drawings of
Louis-Roland Trinquesse." *Burlington
Magazine, Suppl.*, 116 (Feb. 1974), p.
851.
Dijon, Musée des Beaux-Arts.
Exh. cat., Pierre Quarré et al., *Trois
peintres bourguignons du XVIIIème siècle:
Colson, Vestier, Trinquesse.* 1969.

Seated man turned to right, holding a
club

Red chalk. | Inscribed lower right (erased):
Trinquesse; verso: Trinquesse and 32. | Tears
top and bottom edges, lower right corner; spot
on cheek, partially removed; sheet was at one
time folded horizontally across the center. | 620
x 460 mm.

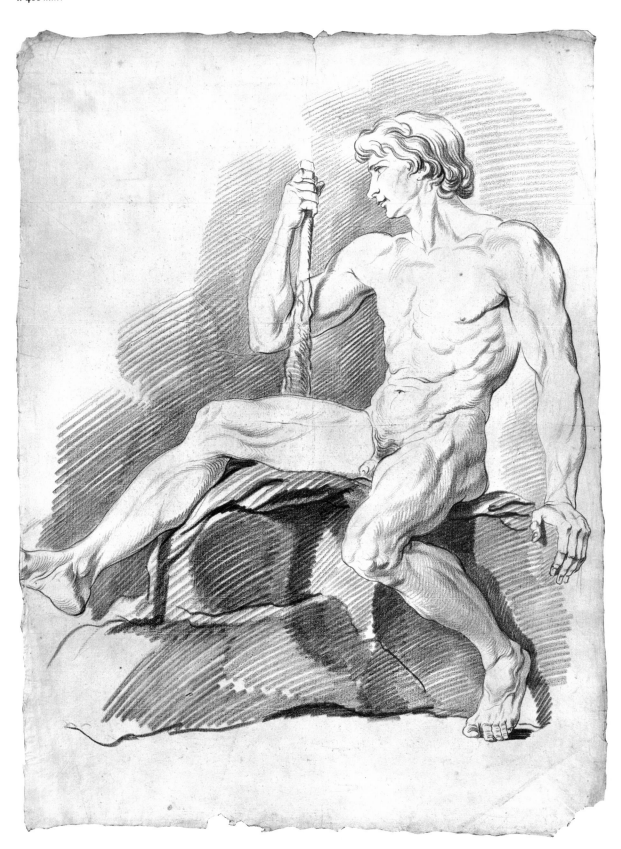

Carle Van Loo

Nice 1705–Paris 1765

33 (opposite)

Man pulling a rope

Red chalk; border in black chalk. / Inscribed lower right in pencil and red chalk: figure jouée par M^r Vanloo; *erasure after the word* jouée. / *Glued to heavy paper mount; stains along bottom edge; repairs in torso, arm, upper left corner, and on bottom edge. / 442 x 281 mm.*

After Natoire departed for Rome in 1751 and Coypel died in 1752, Charles-André (called Carle) Van Loo emerged as the leading painter in mid-eighteenth century France. He began his training under his older brother Jean-Baptiste, with whom he went to Rome to study with Benedetto Luti. The sculptor Legros also influenced the painter in these early years. Soon after his return to France, Carle was aiding his brother in the restoration of Primaticcio paintings at Fontainebleau. In 1724 he won the *grand prix* with *Jacob purifiant sa maison*, which enabled him to return to Rome three years later. He also won the annual prize of the Académie de Saint-Luc with a chalk drawing, the *Refus de Balthasar*. Van Loo attracted the attention of important Roman patrons with his *Apotheosis* at San Isidoro. After his return to Paris in 1734 he continued to rise to the top of his profession, becoming *académicien* in 1735, *professeur* in 1737, *recteur* in 1754, and *directeur* in 1763. In 1749, Van Loo was appointed director of the newly established Ecole Royale des Elèves Protégés and in 1762 was named *premier peintre du roi*.

Examples of Van Loo's large religious paintings can be found at Saint-Sulpice, where he did three scenes from the life of the Virgin. He did extensive decorations for the church of the Petits-Pères and painted a *Carlo Borromeo* for the church of Sainte-Merry. In 1764, Van Loo received the commission for the chapel of Sainte-Grégoire at the Invalides, but died suddenly before this monumental task could be undertaken. Van Loo's contemporaries such as Grimm and Voltaire considered him the greatest painter of his time. Although colder than Boucher—the effect perhaps of the experience of the school of Fontainebleau frescoes—Van Loo's style was thought by extreme members of the neoclassic generation (the *primitifs*, for example) to exemplify the materialism they so condemned in the art of the Louis xv period.

The pose in our drawing reminds one of a Van Loo *académie* in Stockholm (fig. 28), and the model is one we find in a number of his *académies*, for example, in a drawing at the Louvre (fig. 29). The style of our piece, however, while not incompatible with these examples, is more free and flowing in its contours and more spontaneous than the others in its modeling as well as in the hatching used for background and shadow. These anomalies have an interesting explanation, however, the key to which is the drawing's inscription. The erasure after the words *figure jouée* might at one time have said *à 5 points* (though not necessarily in the same hand). In any case, the drawing is not strictly speaking an *académie*, as are the works to which we have just compared it; rather, it is a related kind of exercise or even game (as the term *jouée* implies). The object was to draw a figure whose extremities would touch five points placed on the sheet in advance. Although Van Loo is the only French artist known to have indulged in this exercise—other five-point drawings by him exist at the Bibliothèque Nationale, Paris, at Lyons, and at the Art Gallery of Ontario, Toronto[1]—Pierre Rosenberg believes

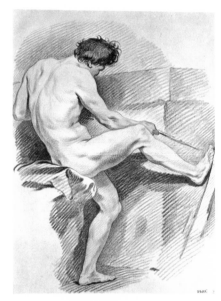

Figure 28. Van Loo, Man pulling a rope, *red chalk. Stockholm, Nationalmuseum, NMH 2911/1863.*

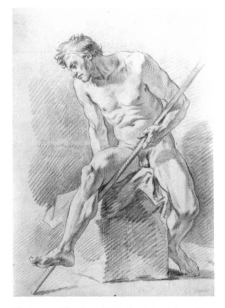

Figure 29. Van Loo, Seated man with staff, *red chalk. Paris, Musée du Louvre, Cabinet des Dessins, 33162.*

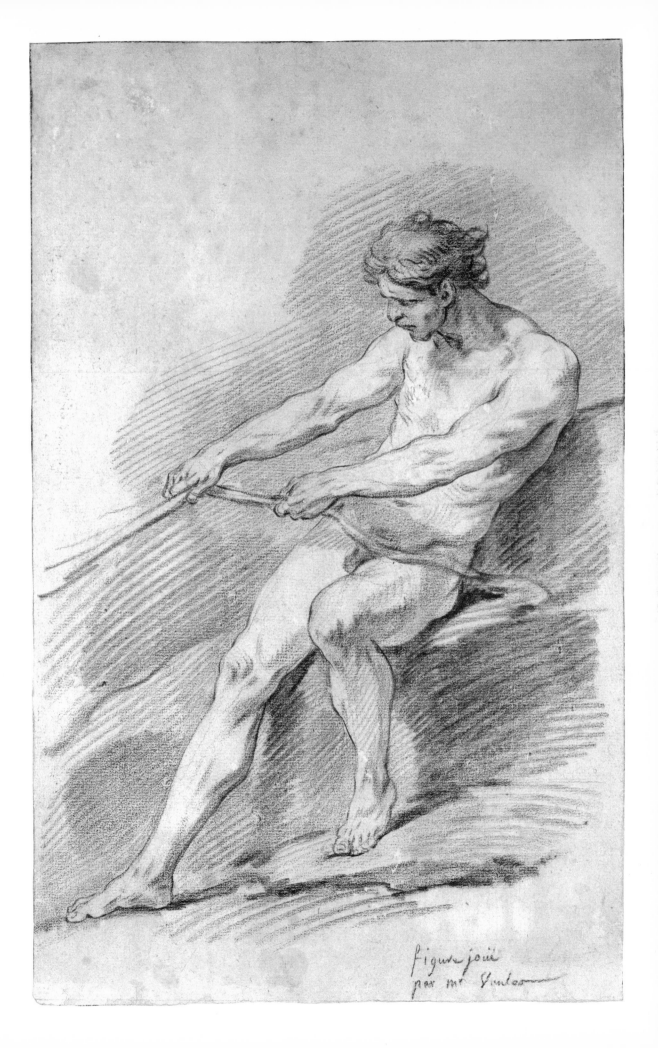

figure joüe
par mr Vanloo

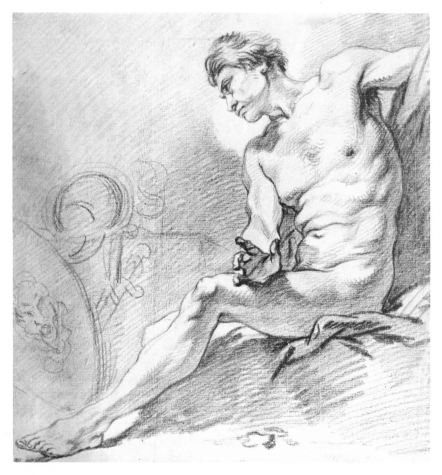

Figure 30. Boucher, Seated man, turned to right, *red chalk. Paris, Musée du Louvre, Cabinet des Dessins, 24756.*

there existed in the eighteenth century a treatise dealing with the subject. A reference to it or a title have yet to be found, however. It might be added that the game was popular among the English.

For his *académies*, Van Loo always preferred red chalk. An excellent example of his draftsmanship, our drawing reveals the sources of his style in both Bouchardon and Boucher. His debt to the former is made even more clear by the cold schematism of his pure *académies*, while this warmer and more fluent piece is more reminiscent of the latter's work in the 1730s (fig. 30),[2] which helps to date it around that time. Its flowing musculature and soft and varied transitions are much more pleasant than the cold precision of his later academic exercises.

J.H.R.

Notes

1. This information was kindly provided by Mademoiselle Marie-Catherine Sahut of the Louvre. I also wish to thank Mademoiselle Sahut for sharing with me the extensive documentation on Van Loo that she gathered in preparation for the Van Loo exhibition in Nice, 1977.
2. In correspondence with me, Mrs. Regina Shoolman Slatkin was kind enough to suggest that the model shown in our drawing is the same as that drawn by Boucher in the 1730s.

Bibliography

Michel-François Dandré-Bardon. *Vie de Carle Van Loo*. Paris, 1765.

Nice, Musée Chéret. Exh. cat., Pierre Rosenberg and Marie-Catherine Sahut, *Carle Van Loo*. 1977.

Louis Réau. "Carle Van Loo." *Nouvelles Archives de l'art français*, 19 (1938), pp. 7–96.

Old man with warrior's helmet

*Black chalk, heightened with white on right
knee and chest, on brown paper. / Stains on
upper right side and left edge; tear on upper left
edge; sheet was at one time folded horizontally
across the center. / 553 x 448 mm.*

More than in any other area, anonymous *académies* abound, and it would be misleading not to include a representative group in this exhibition. The pieces presented here span the chronological period of the exhibition and exhibit a range in quality from the extremely skilled (nos. 36 and 38) to the slightly awkward, though not unpresentable (nos. 35 and 37). No. 34 is the earliest and immediately recalls the work of Boullongne, but it cannot be from his hand. The grizzled old model, the use of black chalk, and the costume props that transform the figure into a warrior are all typical of the very early part of the eighteenth century. The sensitivity of the drawing is reminiscent of J. F. Lemoine (see no. 26), as is the hatching around the lower abdomen and thigh, while the angular, broken contour of the squared knuckles recalls Jouvenet (nos. 21 and 22). The drawing clearly lacks the thick contours and rounded bones of another artist of the post-Le Brun generation, François Verdier, however, though Verdier did do figures of soldiers (fig. 31). No. 34 can

Figure 31. François Verdier (1651–1730), Kneeling soldier, black and white chalk on brown paper, signed and dated 1688. Paris, Ecole des Beaux-Arts.

Seated man turned to right, holding a
rope

*Black chalk, stumped in areas, heightened with
white, on faded blue paper. / Inscribed on mount
in pencil:* Restout fct. / *Small tears on upper
edge; sheet was at one time folded vertically
down the center. / 435 x 505 mm.*

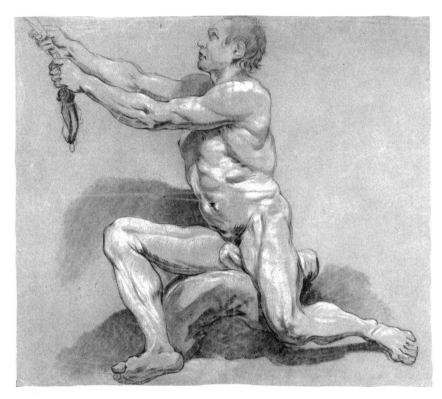

definitely be situated at around 1710,
therefore, and might be compared to
the work of Jean-Baptiste Lemoine the
Elder when more is known about it.

No. 35, which bears an attribution to
Restout on its mount, probably does
date at least from the period of Jean
Restout's activity. Such a hypothesis is
supported by the combination of thick
contour and somewhat slick surfaces,
heightened with white, that recall the
early generation, with the technique
used for background and shadow that
characterize the transitional period
that followed it. The stark realism of
the model's body and of his head,
which seems literally a portrait, are
evidence of the strictly academic set-
ting for this drawing; and this is
further indicated by the presence of
the rope that the model held in order
to keep his pose. The rather awkward
twisting of limbs and shoulders is as
much a reflection of the contorted po-
sition the model was required to as-
sume as it is of the artist's difficulty in
rendering it. The drawing's principal
weakness is the overabundant, heavy,
and haphazard application of the
gouache.

No. 36 clearly reflects the system of
hatching used by Natoire (no. 27), for
example, as on the shaded portions of
the thigh and leg. But compared to a
typical Natoire *académie*, this draw-
ing's angular and sharply defined con-
tour seems too insistent. Though the
bulges of the back are exaggerated, the
artist exhibits an excellent overall abil-
ity to model the anatomy—the arm is
particularly masterful. But around the
buttock the contour has been rather
clumsily redrawn. While the volumes
and proportions of the body are very
skillfully rendered, then, the drawing

Kneeling man with right arm akimbo,
seen from side

*Red chalk, wash, heightened with white. | In-
scribed lower right in pencil: 2775. | Reinforced
by horizontal and vertical paper strips glued to
back; slight stains along bottom edge; sheet was
at one time folded horizontally across the center.
| Watermark: HJ. | 538 x 413 mm.*

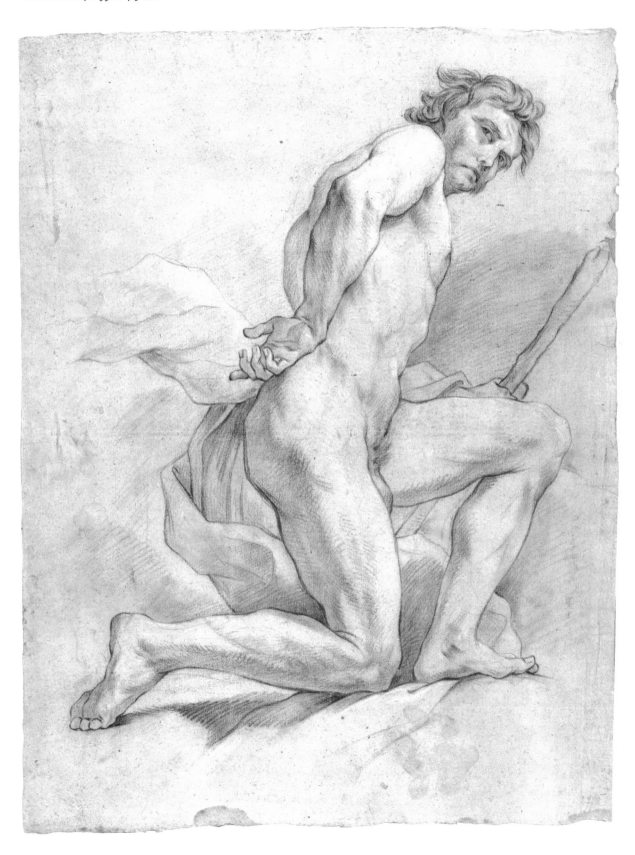

Standing man bending over a support,
seen from rear

*Red chalk. / Small tear on bottom edge; sheet
was at one time folded horizontally across the
center. / Watermark: bunch of grapes with hook,
lettering beneath. / 497 x 384 mm.*

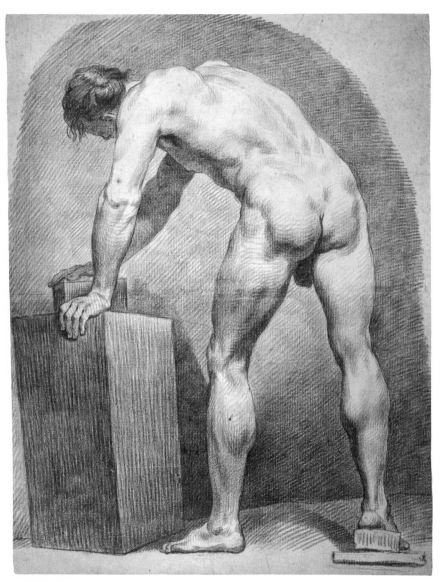

will for these reasons remain problematic until these particular characteristics are discovered to be the trademark of an artist working in the circle of Natoire.

No. 37 is probably a student drawing from the 1760s executed at the Academy. In technique and style it can be compared to a drawing of much higher quality by Suvée from the Ecole des Beaux-Arts (fig. 32). The relative dryness of the execution reveals not only a student work but the increasing tendency of these years toward concentration on frank realism. The wooden blocks used to set the pose and to create certain muscular tensions—note the contraction of the model's right leg muscle—also clearly indicate the schoolroom.

No. 38 is a significant document, since it is dated 1763 and bears the name of the model, Descamps. This information means the drawing must, like nos. 35 and 37, be a schoolpiece, too. Its author, however, was clearly more confident and free in his interpretation of the sitter's anatomy than the artist of no. 37. The hair and the right arm are elegantly drawn, and the muscles of the back and thigh, while too prominent to be pleasing, may imply an expressive intent. The Michelangelesque pose and the model's downcast eyes may suggest a psychological state, in which there was a renewed interest in the 1760s and following years. The chalk is of a very dark red color preferred by the Lagrenée family (in this case it would most likely be Jean-Jacques the Younger) and the draftsmanship is not

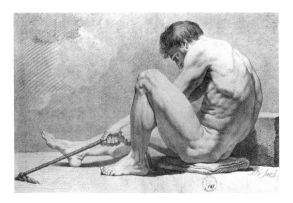

*Figure 32. Joseph-Benoit Suvée (1743–1807),
Seated man pulling a rope, seen from side,
red chalk. Paris, Ecole des Beaux-Arts.*

Reclining man with foot tucked under
knee, seen from rear

*Red chalk. | Inscribed lower left edge in brown
ink: 30 xbre 1763* Mʳ Descamps; *back of mount
in modern hand:* Robert, Hubert, Paris 1733 à
1808. *| Glued to old paper mount; sheet was at
one time folded vertically down the center. |* 413
x 540 mm.

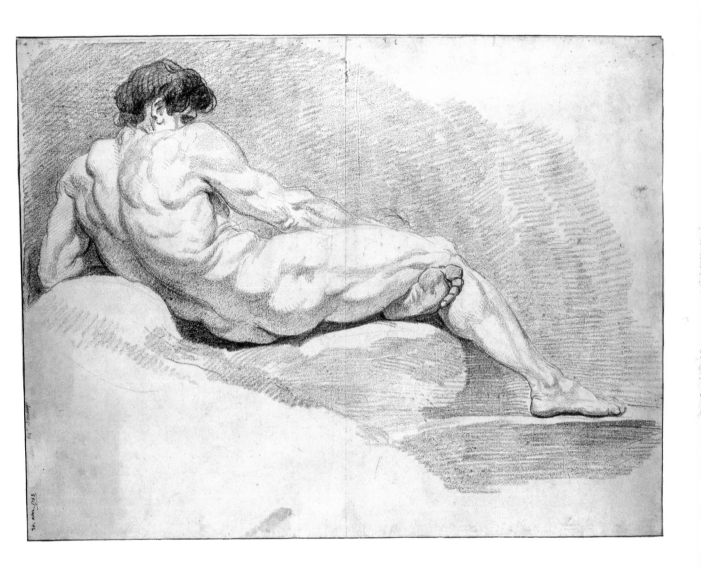

39

Seated man holding a rope, seen from side

Red chalk. | Inscribed lower left: 12 (?); verso at lower right: Vien. *| Surface spotted, perhaps caused by a liquid sprinkled on the sheet that discolored the chalk; trimmed along right edge; sheet was at one time folded vertically down the center. | Watermark: bunch of grapes in a crowned shield; lettering, under which is the date 1770. | 415 x 525 mm.*

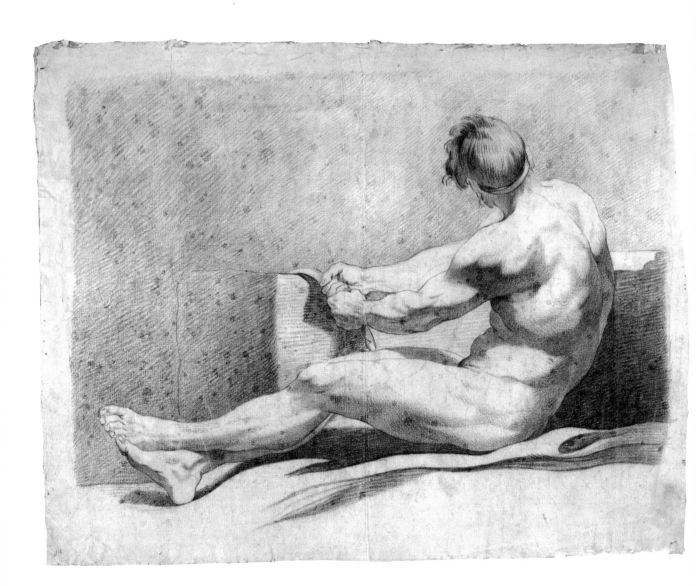

unlike what is known of theirs. Beyond such a tentative suggestion, however, this subtle drawing has eluded all attempts at attribution.

Although no. 39 bears an old inscription on its reverse giving it to Vien, comparison of it to the magnificent figure, also in red chalk but with some white, at the Musée des Beaux-Arts of Tours (fig. 33) brings out strong reservations. The poses, morphology, treatment of the background and even the cloth headband are all admittedly the same, and indeed close comparison of the strokes used to form the ears and the feet and of the systems of shading used to model the figure's muscular relief as well as the surface that supports him may continue to suggest the same hand. But the much greater fluency of the Tours drawing makes ours look rather stiff and mechanical. The confidence of the Tours drawing, on the other hand, clearly recalls the draftsmanship of Vien's famous costume pieces for the "Turkish Masquerade" of 1748,[1] and despite the very tentative rapprochement made by Antoine Schnapper between the Tours figure and David's so-called *Patroclus* at Cherbourg,[2] the Tours drawing, which also carries an inscription or signature, deserves to be retained as part of Vien's oeuvre.

The comparison to David is instructive, however, for, very much under Vien's influence while in Rome, the former acquired a stylistic grandeur derived from contact with the antique, Michelangelo, and the seventeenth century. The windblown hair of the Tours figure is a quotation from the Sistine ceiling, and its pose, like that of our drawing, is reminiscent of the great Florentine. Our drawing, done on paper dated 1770, may then belong to the Vien circle. Its stiffness and lack

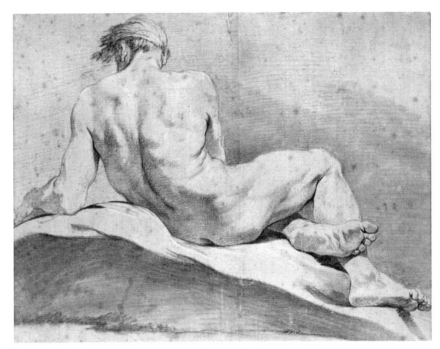

Figure 33. Joseph-Marie Vien (1716–1809), Reclining man, seen from rear, *red chalk. Tours, Musée des Beaux-Arts.*

of warmth correspond to the movement around Vien toward neoclassicism; and in fact such qualities are characteristic of Vien's style in history paintings of these years. Until more is known about Vien's draftsmanship itself, however, it will be difficult to say more about works related to his circle.
J.H.R.

Notes

1. See François Boucher, "Les Dessins de Vien pour la mascarade de 1748 à Rome," *Bulletin de la Société de l'Histoire de l'Art Français*, 1963, pp. 69–76.
2. Antoine Schnapper, "Les Académies peintes et le 'Christ en croix' de David," *La Revue du Louvre et des Musées de France*, no. 6 (1974), p. 385.